IMAGES
of America

DADE CITY

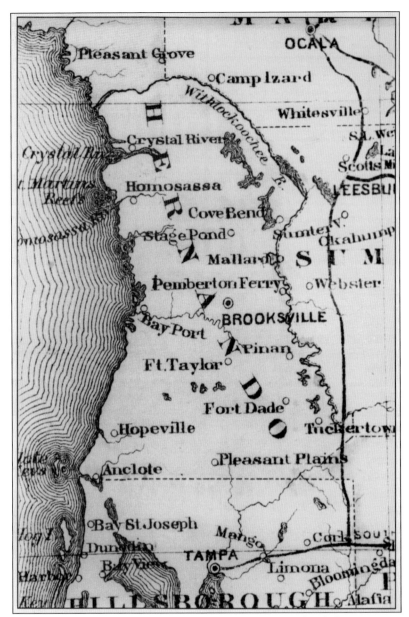

This map, dating from 1870, shows Hernando County before it was divided into Pasco, Hernando, and Citrus Counties. (Courtesy of University of South Florida Library Special Collections.)

ON THE COVER: The Berry & Griffin Drug Store was at the corner of Meridian Avenue and Eighth Street. Men in the photograph from around 1903–1904 include Nathan C. Berry (leaning against the post) and to his left, Henry Clay Griffin. Also believed to be in the photograph are Col. Jefferson A. Hendley and Capt. John B. Johnston. Griffin was a mayor of Dade City and a Pasco County sheriff. He bought out his partner, Berry, soon after the photograph was taken. He built the Griffin Block in Dade City in 1905. Berry and Griffin also owned a drug store in neighboring Trilby, Florida. (Photograph by Winifred Bridge, Helen Eck Sparkman Collection, courtesy of Oliver and Barbara Dewitt; store title/dates from "Era Druggists' Directory," May 21, 1903.)

IMAGES
of America

DADE CITY

Madonna Jervis Wise

ARCADIA
PUBLISHING

Published by Arcadia Publishing
Charleston, South Carolina

Printed in the United States of America

Library of Congress Control Number: 2014933135

For all general information, please contact Arcadia Publishing:
Telephone 843-853-2070
Fax 843-853-0044
E-mail sales@arcadiapublishing.com
For customer service and orders:
Toll-Free 1-888-313-2665

Visit us on the Internet at www.arcadiapublishing.com

This book is dedicated to three unique individuals who happen to be my children: J. Jervis Wise, Esq., Mamie V. Jervis Wise, Esq., and Rachel B. Jervis Wise—you are my life's inspiration!

CONTENTS

ACKNOWLEDGMENTS

I enjoyed serving as an educator in Dade City and the surrounding communities, and was reminded of the cordiality of Dade City as my husband, Ernest E. Wise, and I worked with a team in bringing this book to realization. I appreciated the ongoing collaboration of Jeff Miller of the www.fivay.org site of West Pasco Historical Society.

My sincere gratitude to Oliver and Barbara Dewitt and the late Helen Eck Sparkman, who had the forethought to provide Eddie Herrmann, one of the authors of *The Historic Places of Pasco County*, access to their photograph collection for preservation. Eddie Herrmann, a charter member of the Pasco County Historical Preservation Committee, consulted throughout. His stories of retrieving photographs and documents from rubbish bins and spending hours with Alice Hall and other noted historians provided inspiration. Thanks to Michael Sherman, community development director; John Moors and Melody Floyd, Greater Dade City Chamber of Commerce; Carol Jeffares Hedman, Dolores Lanigan, and Virginia McKendree, Pasco County Fair Association; Dr. M. Dorothy Neuhofer, OSB, Saint Leo University archivist; N. Adam Watson, photographic archivist of the Florida Memory Project; William G. Dayton, Esq. and Glen Thompson, Pasco County Historical Society; J. Thomas Touchton, Tampa Bay History Center Museum; Buddy Jones, Engraving Systems Support Inc.; the late Carolyn Falls, Barbara Russ, and Susan Shelton, Pioneer Florida Museum and Village; Diana Scott, Dade City Garden Club; Cheryl Heath, First Presbyterian Church; Rita Conlin, Saint Rita Church; Margaret Angell, Dade City Merchants' Association; Theresa Pressley, Leslie J. Ruttle, and Allen Altman, Pasco County Schools; Norman Carey; Lora Blocker; Dr. Mary Giella; Dr. Bermice Mathis; Imani D. Asukile; Margarita Romo, Farmworkers Self-Help Inc.; Mamie Wise, Esq.; and Nicholas J. Linville, historian, Southeastern Archaeological Research Inc.

Thanks in particular to the Historic Preservation Advisory Board of Dade City for endorsing the book and offering direction. Members of the Historic Preservation Advisory Committee include Laura Beagles, Scott Black, William G. Dayton, Susan Dudley Maesen, Eddie Herrmann, Levater Holt, Julia Pittman, Doug Sanders, Diane Tsacrios, Jean B. Ward, and Karen Traenkner Koser. The Pasco County Genealogical Society and the Hillsborough Public Library System's Genealogical Collection, along with their librarians, have been invaluable.

Thanks to everyone who contributed to the book via answering questions, relating stories, or sharing a kind smile. The book is intended to be an invitation to learn more about Dade City, and serve as an enticement to walk through Church Avenue, visit the historic courthouse, dine in a vintage café, or visit the Pioneer Florida Museum and Village. History must be shared to pass it to the next generation!

INTRODUCTION

Dade City is a municipality abounding in much-loved pioneer heritage of both the American South and historical Florida. The town has transformed to accommodate economic, social, and cultural change encompassing institutions and trends, yet it retains a matchless charisma. From its agrarian roots to its governmental callings and its addendum of service-related businesses, a stroll through Dade City is somewhat ageless.

Long before becoming known as Fort Dade or Dade City, the locale was emerging. Early human inhabitants date to 10,000 BC. It is widely recorded that the area was occupied by Native Americans of the Muscogee Creek nation when Spanish explorers arrived in the 16th century; however, research does not substantiate this. Dr. Jerald Milanich, author of *Florida Indians and the Invasion from Europe*, attempted to retrace the expedition of Hernando de Soto through Florida. From the Spanish documents he reviewed, he assumed that the expedition passed along a Native American trail in, or very near, present-day Dade City. It was here that the Spanish saw the first native cornfields known as the "Plain of Guacozo." There is no conclusive evidence of which tribe the Spanish encountered; however, many native groups across Florida were decimated by European-introduced diseases, leading to a population "vacuum" by the early 18th century. In the mid-18th century, various southeastern Indians, the majority of whom were Creek, began settling the area. They became known as the Seminole. Beginning in 1835 and until 1842, the United States and the Seminole were at war. Another war (the Third Seminole War, 1855–1858) drove most of the Seminole from the region, encouraging further white settlement.

The settlement that was eventually named Fort Dade began to evolve when James Gibbons was issued a land patent for 160 acres in 1842. The lure of resources such as the Withlacoochee River and newly cleared Fort King Road (1825) brought promise to settlers.

The merchants of Fort Dade moved to a new site to be near the railroad, and the new site was named Dade City. The new city needed a post office, and the most expedient course of action was to move a post office rather than apply for a new one. Minza G. Rowe transferred the existing post office to the new town and applied to change the name from Hatton to Dade City. Pasco County was established from a region of Hernando County on June 2, 1887, by Gov. Madison S. Perry; Dade City became the county seat.

Government affairs were conducted in a frame building owned by Henry W. "H.W." Coleman and William N. "W.N." Ferguson, which was utilized until 1889, when a permanent courthouse was erected. In 1909, it was replaced by a domed brick structure.

Milestones mark the path of Dade City's history, and a stroll through 21st-century Dade City reveals remnants and clues of many landmarks. The first newspaper, the *Fort Dade Messenger*, was published in 1882. The Dade City Hotel opened for business in 1886. An array of churches sprouted, including the Methodist church on College Street, erected in 1889 by James E. Lee; the First Presbyterian Church of Dade City; and the College Street Baptist Church (later known as First Baptist) in 1891. Others included Bethel Primitive Baptist Church in 1885, Saint Mary's Episcopal

Church in 1909, Saint Rita Catholic Church in 1913, Mount Zion African Methodist Episcopal Church in 1918, and Saint Paul Missionary Baptist in 1925. The brick jail constructed in 1892 as a garrison to secure alleged lawbreakers, on Robinson Avenue and Tenth Street, survives.

Dade City was known for turpentine and lumber from after the Civil War until World War II. Open range was the norm for the cattle industry until the late 1940s. The Great Freezes of 1894–1895 destroyed the abundant citrus groves. Sunnybrook Tobacco Company was Pasco's largest employer from 1908 until 1920 when black shank, a potent tobacco disease, virtually eliminated the commodity in east Pasco. Citrus cultivation was revitalized soon after, and the Pasco Packing Association (Lykes-Pasco) opened in 1936. Later known for pioneering the development of citrus concentrate, Dade City embodied the packing industry until the 1980s, when several brutal freezes again annihilated citrus.

As for technology and innovation, in 1903, Pasco County Telephone Company laced wires from Dade City to Blanton, Jessamine, Saint Leo, and San Antonio. In 1908, electricity reached Dade City via the Dade City Ice, Light, & Power Company.

As open-range Florida was being fenced in, ranches converted from cracker cattle to purebred. Ranch operations with spacious pastures are reminiscent of early Florida. William Larkin brought the first Santa Gertrudis bull to Florida around 1950. The fourth generation Barthle Brothers Ranch is known worldwide for its purebred Brahman cattle and American Quarter Horses and hosts National Cattlemen's Association events. The Blanchard Ranch, which formerly hosted the Little Everglades Steeplechase, entices international equestrians for the Foundation International Combined Horse Driving Events annually.

The formal opening of the Hotel Edwinola in 1912 must have been quite the societal gala, revealing the social grace of this delightful city. Today, one can catch glimpses of folks as they dine at the Dade City cafés carved from historical roots. The newspaper most identified with the town, the *Dade City Banner*, came into existence in 1913, and although it closed its doors in 1973, the archives at the Hugh Embry Library are well preserved in microfilm, recently converted for digital access. Imagine, too, that Dade City boasted a 12-bed hospital in 1926.

The World War II bandstand monument stands gloriously in the center square and reflects the city's patriotism and prideful respect. Research reveals that Dade City hosted a prisoner of war camp from 1942 to 1946 during World War II. Prisoners were mostly German soldiers (Rommel's Afrika Korps, captured in North Africa, and U-boat sailors) who manufactured limestone bricks, built warehouses, and assembled shipping boxes in Dade City and surrounding communities.

Schools date back to Fort Dade Academy in the 1850s, but public education became more prevalent when the Pasco School Board was created in 1887. Educational institutions throughout the area's history owe gratitude to a teacher's certification program in the South Florida Normal School, which trained and certified teachers from around the state. The tradition progressed with the 1967 establishment by the Florida legislature of Pasco-Hernando Community College and its subsequent 2014 designation as Pasco-Hernando State College.

The Pioneer Florida Museum and Village was opened on Labor Day in 1975, featuring a living history exhibit that included a 1913 locomotive, pioneer school, the Trilby Train Depot, and much more.

Tennis star and native son Jim Courier proudly announced at the 1990 French Open that he was from Dade City. Courier proclaimed in 2007, "physical restoration of Dade City has created a quintessential turn-of-the-century southern town."

An abundance of community-sponsored events have emerged in the 21st century that showcase Dade City's history, including the Kumquat Festival, Church Street Christmas, Country Christmas Stroll, Pasco County Fair, and Rattlesnake Festival in San Antonio. Each gives a sampling of the grace of this remarkable place.

One

A Historic Walk

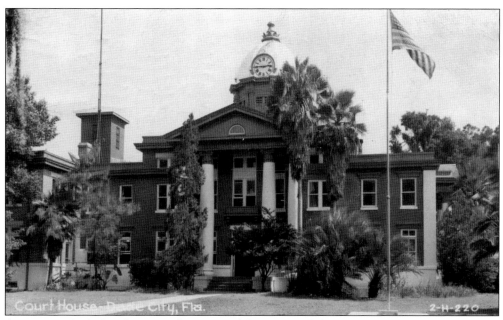

Any visit to Dade City begins at the center of the town and the Pasco County Courthouse. The courthouse was designed by architect Edward C. Hosford of Georgia, who drew blueprints for courthouses throughout Florida, Georgia, and Texas. Mutual Construction Company erected the courthouse, with local architect Artemus Roberts as supervisor. It was approved for use in January 1910. From the courthouse, one can take a variety of paths to view the historic sites. Consider the city's walking publication, or Steve Rajtar's historical trail guide. (Courtesy of Eddie Herrmann, Historical Preservation Committee.)

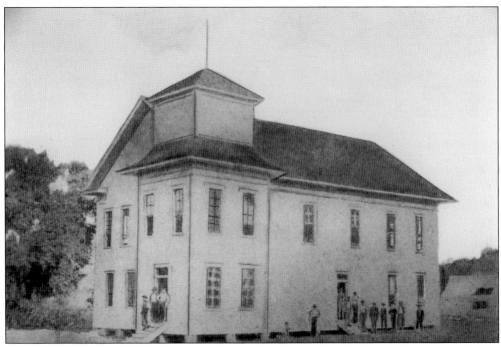

The first official courthouse was preceded by a temporary edifice owned by Coleman & Ferguson. James Lee and Henry Clay "H.C." Griffin constructed the $7,000 wooden structure, which was donated for use as a courthouse. It was located about a block west of the historic courthouse, and later succumbed to fire. (Courtesy of Scott Black.)

County Commissioner Sylvia Young coordinated a $2.3 million renovation of the historic courthouse in 1999, including the selection of period antique furnishings. Many vintage pieces were donated by Tom Dobies. (Courtesy of Florida Library & Archives, Florida Department of State.)

The first-floor courthouse meeting room is adorned with a painting of Sen. Samuel Pasco (1834–1917). Pasco was a Harvard scholar, Civil War hero, and lawyer. He had been a schoolmaster in Florida's Panhandle and, when the Civil War broke out, enlisted in the Confederate Army. (Courtesy of Ernest Wise.)

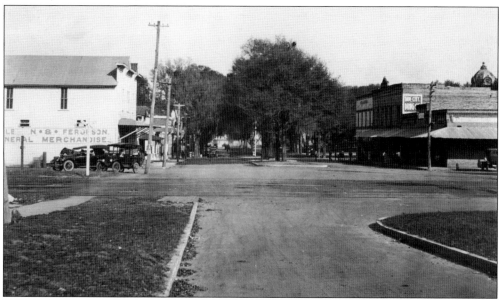

H.W. Coleman and W.N. Ferguson met in Georgia where Coleman worked as a clerk for Ferguson's father. In 1884, they ventured to Florida and purchased a lot in the original section of town from Reuben Wilson. It was the second general store; the first had been built by W.C. Sumner. They opened the store 10 days after construction began. In this view of Meridian Avenue looking east from Tenth Street, the store is visible on the left. Over the years, it occupied several different Meridian Avenue locations. (Sparkman Collection.)

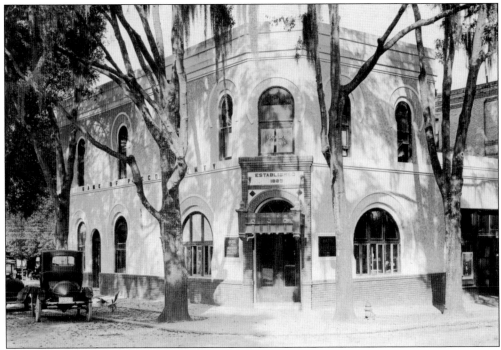

The Bank of Pasco County was a brick structure on the northeast corner of Meridian Avenue and Seventh Street. It was incorporated in 1889—the third oldest state bank charter in Florida. It was one of the few banks that survived the stock market crash. The Wells Fargo bank that currently occupies the building completed a renovation with similar brick and structural design. (Courtesy of Jeff Miller.)

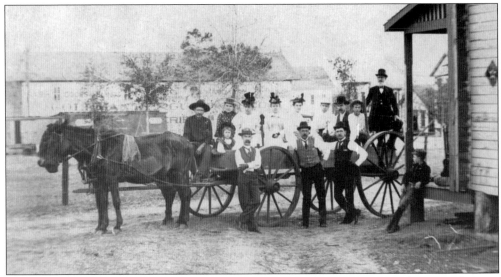

Pictured with this two-horse wagon is an ensemble of Dade Citians adorned in period attire, including hats and parasols, posing for a photograph in 1887. William Dayton identified the driver as 1900 census taker and real estate broker Capt. Clinton E. Spencer. Over 100 years later, Florida governor Lawton Chiles labeled Dade City as Florida's Outstanding Rural Community of 1994. (Courtesy of William G. Dayton.)

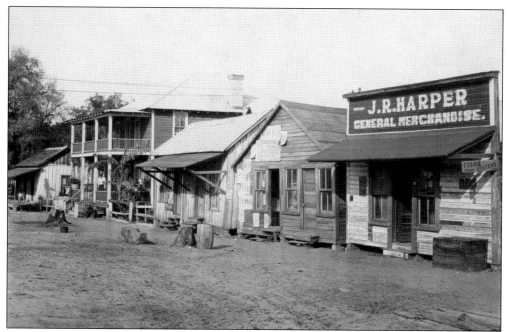

This photograph of Jim Rowe Harper's store on Seventh Street shows rustic establishments and dirt streets. An election in 1889 to name the Pasco county seat was quite political, but Dade City won, with 432 votes, over Pasadena (96), Urbana (20), Clear Lake (2), Jefferson (2), and Owensboro (1). (Sparkman Collection.)

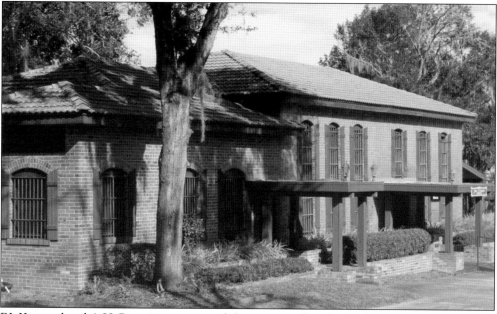

F.J. Kennard and A.H. Ravesies constructed the county jail at the northeast corner of Robinson Avenue and Tenth Street in 1892. The oldest brick building in town, it has been preserved by businessman Buddy Jones, who related that the building contains the original iron bars over the once double-hung windows and all authentic sections except the sheriff's residence on the east side. In the 1890s, a wooden gallows was stationed on the west side. (Courtesy of Buddy Jones.)

In 1885, Dade City was already thriving and listed in Webb's *Historical, Industrial & Biographical Florida*. The nearest shipping points in frontier Dade City were Wildwood and Tampa. Dry goods and groceries arrived by wagon. (Courtesy of Laveda Martin Rogers.)

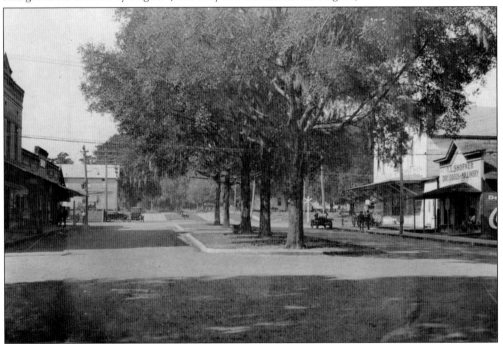

This photograph shows early Dade City from Meridian Avenue at the corner of Seventh Street. Settlers made treks to Tampa often by oxen teams, with several neighbors joining forces for the trip, which generally took three days. (Sparkman Collection.)

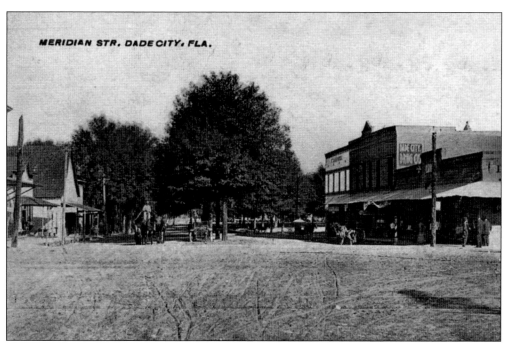

Reminiscent of pioneer Florida, horse and buggies appear in downtown Dade City. Flora E. Staley, wife of Edward M. Staley, said, "These were busy days; each housewife did all her work, but found time for neighborly visiting, or to gather at the river or lake for an all day picnic or fish fry. The young people would meet in the evening for a dance, to play games or to have a song service." (Courtesy of Polly Hamm.)

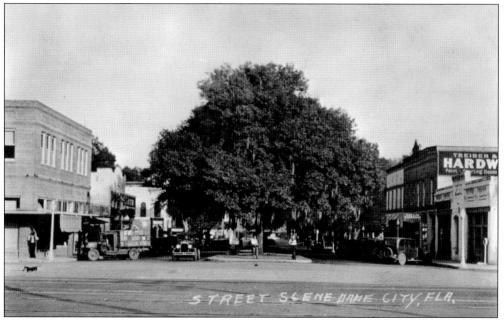

The Treiber building was constructed around 1900 as a hardware store. Painted on Treiber's in 1932 was an enticement for "Paints, House Wares, Farm Tools, and Sporting Goods." (Courtesy of Florida Library & Archives, Florida Department of State.)

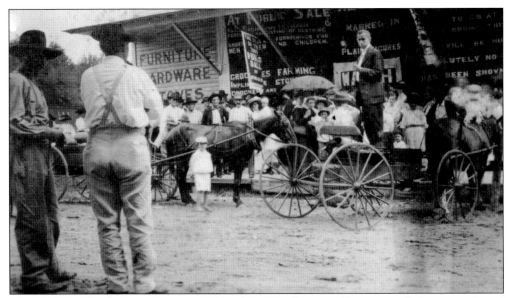

This photograph of an auction in Dade City shows two horse and buggies, with farmers gathered for the event. (Courtesy of Pioneer Florida Museum and Village.)

The American Legion Hall Post 15 on the north side of Church Avenue between Ninth and Tenth Streets was next to the site of a blacksmith shop. In 1919, the stucco concrete-block building was erected for use as a meeting location. The post was named in honor of Gordon M. Crothers, who was killed in France during World War I. (Sparkman Collection.)

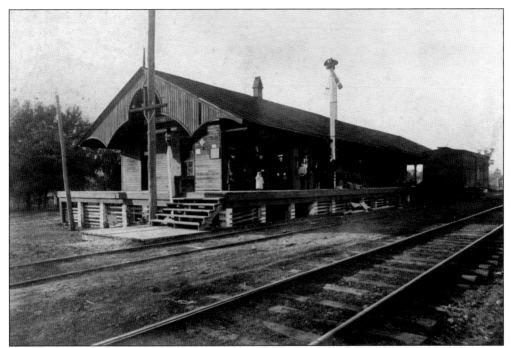

The Atlantic Coast Line railroad depot is located on US Highway 98 and the 301 bypass. This photograph shows the earlier wooden depot that was replaced by the current brick depot. The first rail line reached Dade City in 1887. Railroads opened market access for local products. (Photograph by Ray McMahan; Sparkman Collection.)

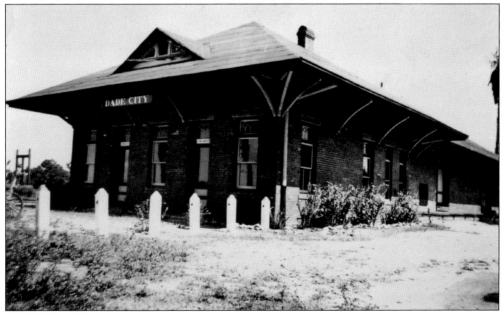

The replacement depot was built in 1912 about a quarter mile north. Two additional rail lines were built through Pasco County by 1890. Typical of railway architecture of the period, the depot has survived without major alteration. Dade City acquired the building from CSX Transportation and used federal funding to renovate it in 1996–1997. (Courtesy of Black.)

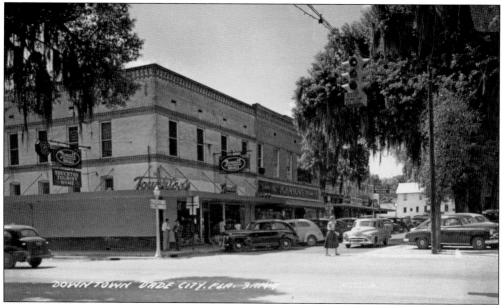

The 1908 Touchton Drugstore symbolizes Americana. Master storyteller William Porter (O. Henry) penned in 1908 "The Hand that Riles the World," a story about everyday people that mentioned Dade City. In the story, Jeff Peters and Andy Tucker attempted to land a governmental post for Bill Humble. After some plotting and belief that they had succeeded in deluding a prominent female lobbyist, they learn, ironically, that Humble was granted not the Wild West marshal position, but postmaster of rural Dade City. (Courtesy of Florida Department of State.)

Dade City Waterworks, located at the northeast corner of Tenth Street and Church Avenue, was built in 1915 by E.V. Camp & Associates as the first public water system in Pasco County. (Courtesy of Wise.)

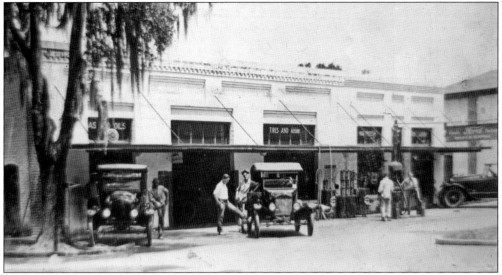

The Ford Shop was operated by Mack Clyde "M.C." Autrey, at the northeast corner of Meridian Avenue and Sixth Street. In the foreground is Edward Denton. A favored spot in 21st-century Dade City, the quaint restaurant Kafé Kokopelli occupies the space. The civic-minded team of Gail and Glen Greenfelder renovated the Ford Shop, which was constructed around 1916. (Courtesy of Herrmann.)

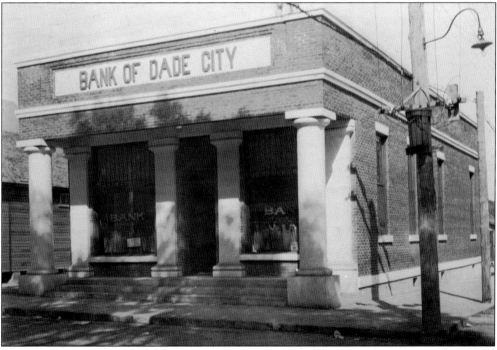

The Bank of Dade City on the northwest corner of Meridian Avenue and Seventh Street opened on June 29, 1916. It currently houses Quilts on Plum Lane. The *Dade City Banner* reported on July 13, 1926, "The Bank of Dade City failed to open its doors this morning and a notice posted on the door stated that the directors had decided to close the institution, as the cash reserves were below the legal requirements." (Courtesy of Miller.)

The city hall was built in January 1917, and today rests nobly in the same location, the northwest corner of Meridian Avenue and Fifth Street. Over time, it has been the site of a gift shop, newspaper office, barbershop, law office, bail bonds office, and even a bridge club. (Sparkman Collection.)

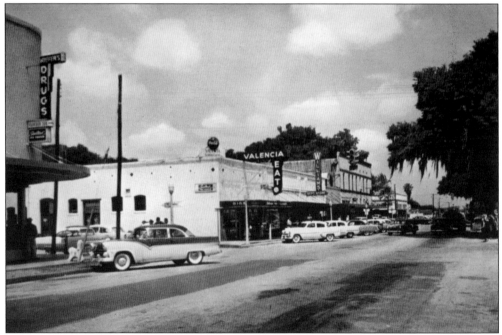

The Williams building across from the courthouse on Seventh Street was constructed of brick and opened in 1919 by O.N. Williams as a dry goods store. The business was later managed by his sons, Virgil and J.R.A. "Bob" Williams. One of the area's most well-known cafés, Lunch on Limoges, is housed at Williams Department Store. (Courtesy of Florida Department of State.)

Meridian Street, Residence Section, Dade City, Fla.

Until 1920, Dade City had only scattered electric lights downtown. Charles F. Touchton was appointed chairman of the street lighting committee and plans were made to create a "white way" on Meridian Avenue from the Seaboard tracks east to the Atlantic Coast Line depot. With the great oaks arching over the streets and the new night lighting, Dade City became known as one of the prettiest towns in central Florida. The Osceola Hotel on the southwest corner of Fifth Street and Meridian Avenue, built by Rev. Mozelle L. "M.L." Gilbert, served as a boarding house. (Courtesy of Miller.)

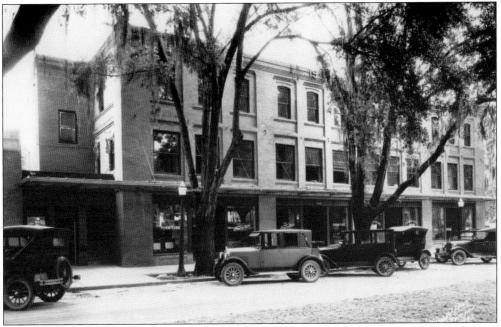

"It was the custom in the 1920s through the 1940s for the ladies to do their marketing in mid-morning and then meet at one of the drug stores for 'cokes & conversation,' a forerunner of today's coffee break," said Thelma Touchton. (Photograph by Burgert Brothers, courtesy of Tampa-Hillsborough Public Library.)

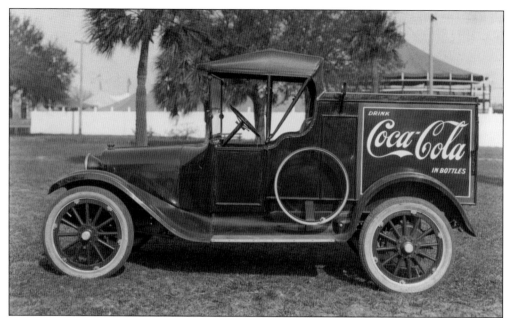

Dade City Coca-Cola Bottling Company, built in 1920, was located on Seventh Street south of the telephone company. George A. Gilbert, a steamboat engineer from Leesburg, Georgia, purchased the plant with his brother-in-law, G.H. Boring. Gilbert was married to Alice Jordan, daughter of early pioneers Henry and Eliza Lanier Jordan. The Coca-Cola bottles were embossed with "Dade City, Florida." Gilbert also bottled fruit flavored drinks under the Gilbert and Southway labels. (Photograph by Burgert Brothers, courtesy of Tampa-Hillsborough Public Library.)

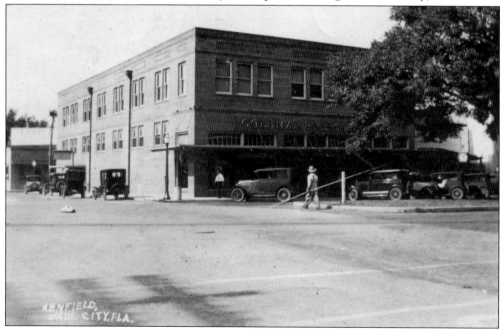

Known as the department store that had everything, including caskets, the original Coleman & Ferguson was replaced with brick in 1923. Remodeled in 1987, the 20th-century building is known as the Centennial Building on Meridian Avenue. (Courtesy of Miller.)

The telephone building was constructed in 1924 on Seventh Street between Pasco and Church Avenues by the Florida Telephone Company under the direction of its founder, Otto Wettstein. For many years, it housed the main switchboards. More recently, it has been home to A Matter of Taste Café & Tea Room. (Courtesy of Miller.)

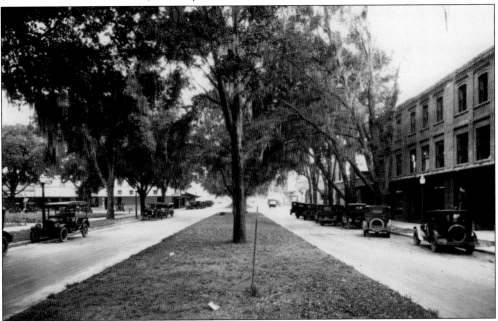

Dade City experienced an unusually cold winter in 1925, followed by an extremely hot summer. A series of freezes and hurricanes sent Florida into a tailspin, causing the collapse of the Florida Boom just three years before the Great Depression. (Photograph by Burgert Brothers, courtesy of Tampa-Hillsborough Public Library System.)

Dade City Municipal Hall on the southwest corner of Meridian Avenue and Fourth Street, which was built to be a hotel in 1925, was demolished in 2013. Former Dade City mayor Lawrence Puckett said, "The city hall was to be a six-story hotel but due to the approaching end of the boom, it failed at the fourth floor slab. The city reclaimed it for nonpayment of taxes. Due to assistance from Mr. A.F. Price and the WPA, it was converted to a city hall." It was named for George C. Dayton, who retired as city attorney after 30 years of service. (Courtesy of Miller.)

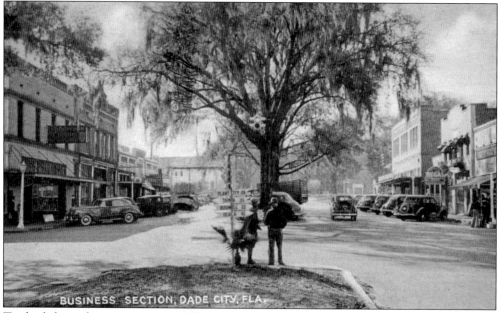

To the left on this street one would have found Touchton Drug Store (Charles Floyd "C.F." Touchton) along with Treiber Hardware, A&P Grocery, a millinery shop, Nabers Jewelry Store, and Fred Touchton's Drugstore on the same block. On the back of the same block (which would have faced the old Seaboard depot) were IGA Grocery and Cochrane's Furniture Store, which later became Madill's Furniture Store and still later, Harper Furniture. (Courtesy of Black.)

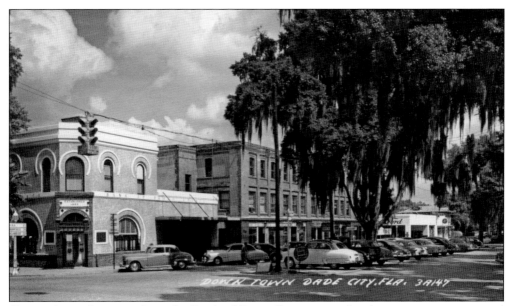

Gazing down the street from the Bank of Pasco County reveals a burgeoning town around 1940. Mamie Lee Capps Douglas wrote in *East Pasco's Heritage* for the US centennial, "The area surrounding Dade City was a thick forest of virgin pine trees. These attracted the attention of five Florida men interested in the fast-growing turpentine and lumber business. They decided that such natural wealth must bring growth enough to Dade City to warrant the establishment of a bank. These men were A.A. Parker and C.E. Newell of Tavares; Russell T. Hall and M.T. Hall of Jacksonville; and J.C. Pace of Altoona." (Courtesy of Miller.)

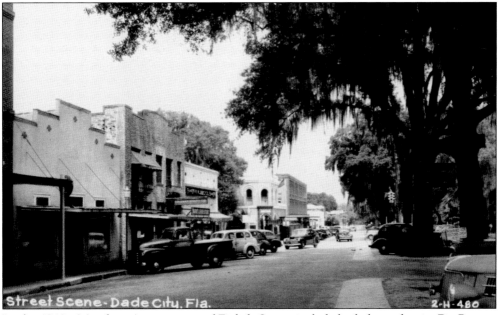

In the 1940s, Meridian Avenue west of Eighth Street included a bakery, dentist Dr. Roscoe Hendley, and the Gandy Building, which contained an office on the first floor occupied by Sara E. Coleman, one of the first female real estate agents. The Bank of Pasco County is in the background. (Courtesy of Henry Fletcher.)

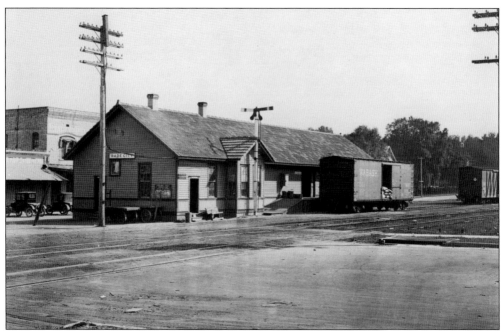

The original Seaboard Air Line (SAL) depot is surrounded by telegraph poles with the town in the background above. It was located at what is now the Eighth Street parking area south of Meridian Avenue (in front of present-day Old Market Bistro & Annetta's Attic). Civic outcry demanded a more up-to-date depot building, which resulted in the Mediterranean-style depot pictured below. Due to the merger of ACL and SAL, the SAL rails were pulled up by the early 1970s, and the linear rail bed from north of Lock Street to south of town was donated by Seaboard Coast Line to the city, which has used it as the Hardy Trail. (Above, courtesy of Black; below, courtesy of Miller.)

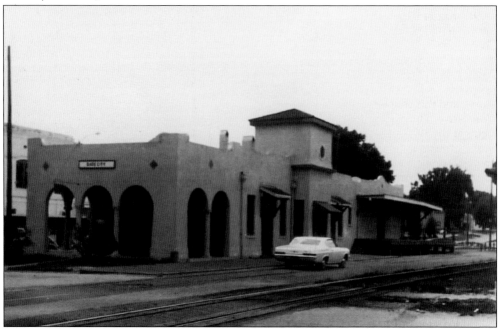

Two

THE TREASURED HOUSES

The historical houses detailed in this chapter loosely follow four geographical regions: Church Avenue, Meridian Avenue, Fifth Street, and Cosmopolitan Dade City. Many groups have acknowledged houses, and this chapter is not all-inclusive. The exploration begins at the 1920s-era Washingtonian palm tree on Church Avenue and Eighth Street, as one begins a journey along historic Church Avenue. The plaque adjacent to the tree marks the Hardy Walking Trail (in honor of Martha and Roy Hardy for their community service). It is surrounded with Arbor Day trees from the Dade City Garden Club and benches from Sunrise Rotary. (Courtesy of Wise.)

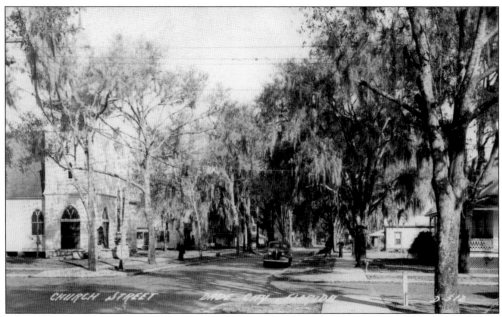

Church Avenue was designated a national historical site in 1997 due to its history of elegant homes and churches from bygone eras. In 1921, Dade City spent $2.35 each day to buy and spread sawdust to fill in the ruts on its dirt street, paving it with brick in 1924. (Courtesy of Florida Department of State.)

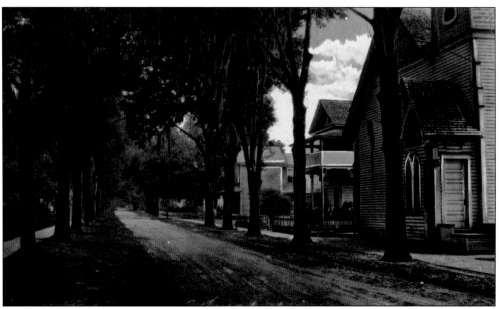

The Methodist church pastor's residence and I.W. Smith's home are shown in this early image of Church Avenue. (Courtesy of Florida Department of State.)

The James Knox Ward home was built in 1890 on the northwest corner of Church Avenue and Ninth Street. Ward resided here beginning in 1896, and was paid $1 per month to store the city's fire equipment. Ward was a carpenter, blacksmith, town councilman, and mayor from 1903 to 1904. His wife took in boarders. (Courtesy of Wise.)

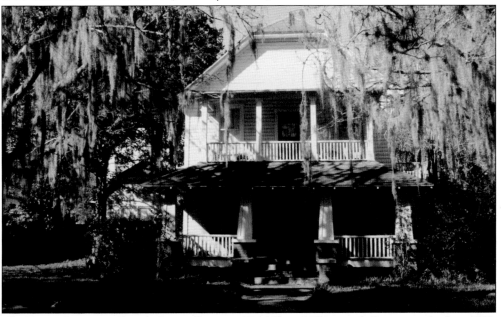

The Tipton house on Church Avenue between Twelfth and Thirteenth Streets was built in 1918. Harry and his wife, Valencia N. Tipton, owned a bakery on Meridian Avenue that was known for scrumptious bread sticks. The full-width porch adds particular charm to the house. (Courtesy of Wise.)

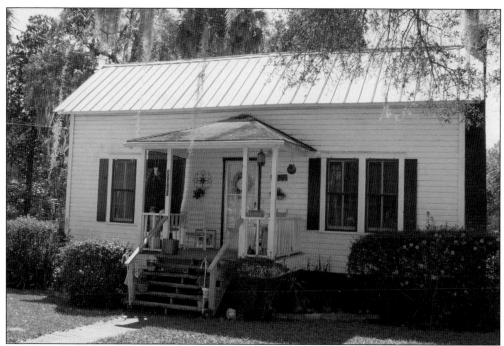

The R. James McCutcheon house was built on the southwest corner of Church Avenue and Tenth Street. McCutcheon was elected to the town council in 1900. (Courtesy of Wise.)

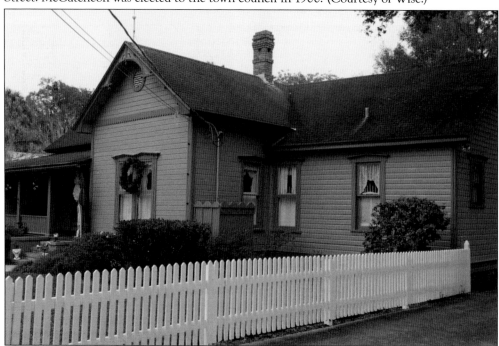

The Charles A. and Catherine H. McIntosh home on Church Avenue was built in 1893 between Tenth and Eleventh Streets. Catherine was an employee of the circuit court clerk and was the society editor of the *Dade City Banner*. Catherine's grandfather was James E. Lee, who built the original Methodist church using heart pine and cypress. (Courtesy of Wise.)

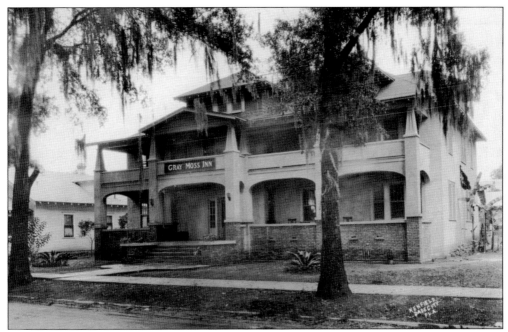

The Gray Moss Inn at the northwest corner of Church Avenue and Eleventh Street was built around 1905 by Jefferson Sumner. From 1946 to 1953, Jack and Carolyn Dudley ran the Gray Moss Inn. Pres. Calvin Coolidge stopped at the inn for lunch as he traveled to Polk County for the dedication of Bok Tower in February 1929. (Sparkman Collection.)

The Parsonage House, built in 1925, was originally part of the Gray Moss Inn complex. It features a full-width porch with wood piers on a solid brick balustrade. It served as the First United Methodist parsonage for many years. (Courtesy of Wise.)

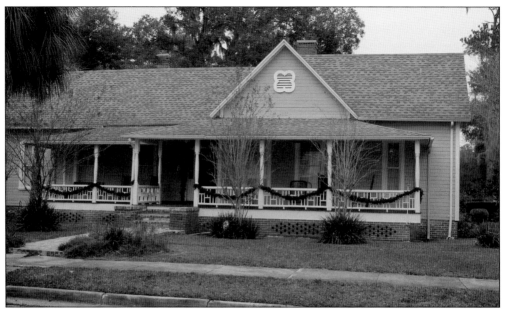

The William Larkin house is at the northwest corner of Church Avenue and Twelfth Street. It was built by Albert Collins in 1895. Larkin, a prominent attorney, civic activist, and rancher/cattle breeder, purchased the house in 1924. (Courtesy of Historic Preservation Advisory Committee.)

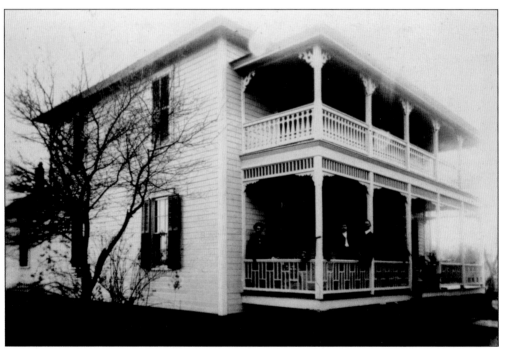

This house, at the southwest corner of Church Avenue and Thirteenth Street, was built about 1887, and was the residence of John W. and Mary J. Platt. They sold it for $1,200 in 1894 to the Methodist church, which used it for over 10 years as a parsonage. In 1905, it was sold to the Jasper C. Carter family for $1,500. The Carter estate sold it 50 years later to Stanley Cochrane, who modernized it. (Sparkman Collection.)

This one-story masonry vernacular house was built by James Ward & Sons on Church Avenue between Twelfth and Thirteenth Streets. He pioneered the use of contrasting colored bricks set in a checkerboard pattern between vertical redbrick piers. Sarah Ward was a teacher in Dade City. James was the son of James K. Ward Jr. and Kate Ward and grandson of James K. and Ascha Ward. (Courtesy of Wise.)

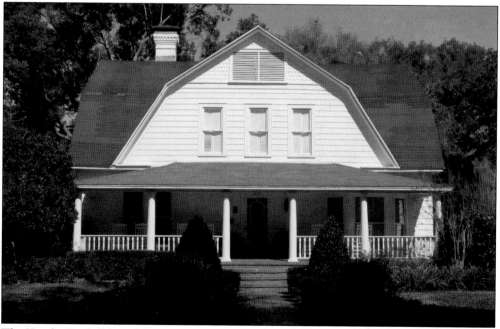

The Knight-Futch-Edwards home on Church Avenue and Thirteenth Street with a gambrel roof was built in 1901. Residents included Emma R. Knight and Dr. Irvin S. Futch, a local dentist and his wife. Judge James Sanders rented the house from 1928 to 1935, and Charles and Sallie Edwards, citrus growers, owned the home from 1942 through 1977. (Courtesy of Wise.)

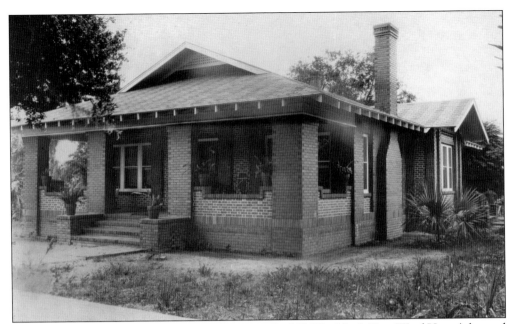

The Ward-Johnson home (referred to as the James "Jim" K. Ward Jr. & Kate Ward House), located at the southeast corner of Church Avenue and Thirteenth Street, was built by Ward in 1926 for his family. Ward built some of the early buildings at Pasco Packing Association in the 1930s. The brick bungalow has a Flemish bond composed of contrasting red and dark colored bricks set between vertical redbrick piers. (Sparkman Collection.)

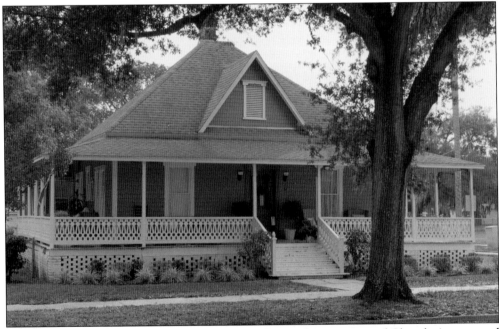

The Raymond-Brown-Lock House is located as the southeast corner of Church Avenue and Fourteenth Street, and was built for John Raymond around 1887. Raymond was elected in 1898 as a town councilman and served several terms until 1904. Grace Lock, the first Pasco County school librarian, also owned the house. (Courtesy of Historic Preservation Advisory Committee.)

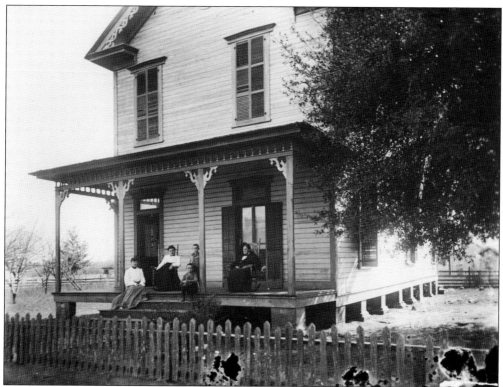

The Cochranes' house, at the southeast corner of Fourteenth Street and Howard Avenue, was built during the 1890s. Malcolm Cochrane and his wife, Mary (Minnie) Ravesies Cochrane, operated the Osceola Hotel. The children were Inez, Lula, Ethel, Will, and Fred. The community respected Lula, a school teacher, and Fred, a star baseball player. (Sparkman Collection.)

The Shoard Home, on Fourteenth Street between Howard and Florida Avenues, was built around 1912. H.C. "Happy" Shoard operated the Lacoochee Bakery. (Courtesy of Wise.)

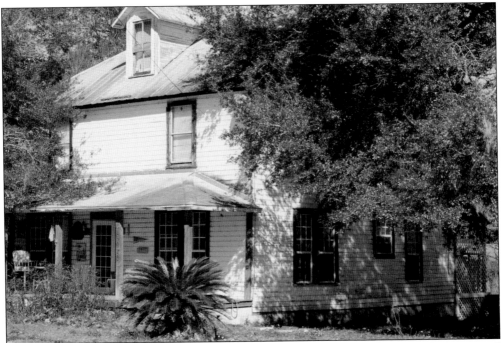

Sheriff I.W. "Ike" Hudson built his home at the northeast corner of Fourteenth Street and Florida Avenue in 1912 for his family, which included 11 children. Ike's parents were Isaac and Amanda Hudson, founders of the town of Hudson. Ike passed away in 1972 at age 102. (Courtesy of Wise.)

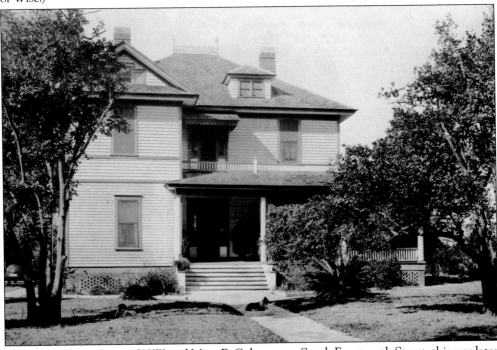

Originally the residence of H.W. and Mary E. Coleman on South Fourteenth Street, this was later the home of Emily Larkin, a *Tampa Tribune* Dade City correspondent. (Sparkman Collection.)

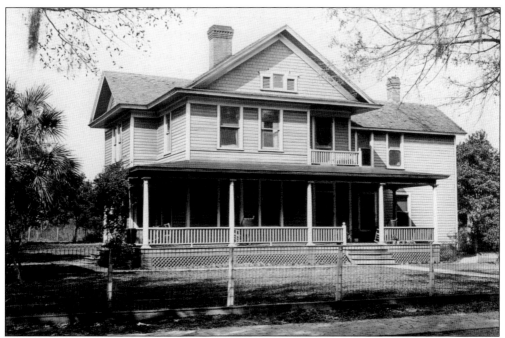

The Dr. Robert Don "R.D." Sistrunk Home, at the northwest corner of Church Avenue and Fourteenth Street, was built in the 1890s. The first established medical doctors were R.D. Sistrunk and John T. Bradshaw, who arrived in the mid-1920s. Their office was on Meridian Street. Sistrunk served as mayor in 1914. (Sparkman Collection.)

The Folk Victorian house on the south side of Church Avenue between Fourteenth and Sixteenth Streets has Queen Anne influences. It was occupied by Isabella McGeachey and purchased by the J.T. Futch family. Reuel and Marie Futch Platt also occupied the house. (Courtesy of Wise.)

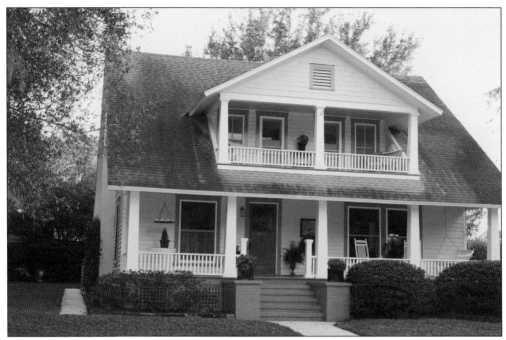

Built in 1910, the Hamilton-Slough House, on the south side of Church Avenue between Fourteenth and Sixteenth Streets, was occupied by Carlos G. Hamilton. Everett Stanley "E.S." Slough, a citrus grower in the area, also owned the house for many years. The current owner, Pat German, said in 2010, "Church Christmas is a great tradition . . . it takes a lot of work, time and money, but this is our gift to the community." (Courtesy of Wise.)

Built in 1947 for Wesley and Jean Ward, this Church Avenue house was built by Ward Contractors. The original house was a square stucco residence with redbrick vertical piers and a front porch. Wesley was Dade City's building/zoning ordinance administrator for 21 years. Jean taught school in Dade City for 36 years. (Courtesy of Wise.)

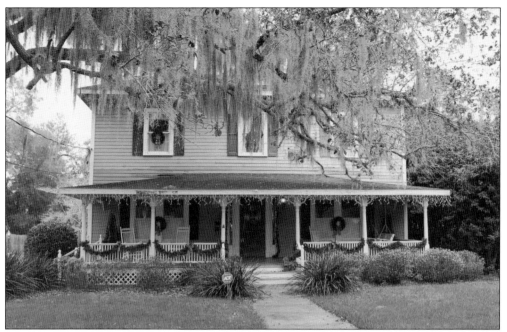

Rev. R.N. Abraham built this home around 1922 at Church Avenue and Fifteenth Street. He was a pastor at the First Presbyterian Church from 1915 to 1919. Dr. Thomas F. Jackson purchased the home in 1926. Jackson utilized it as a two-room hospital until 1935, when he established Jackson Memorial Hospital. (Courtesy of Wise.)

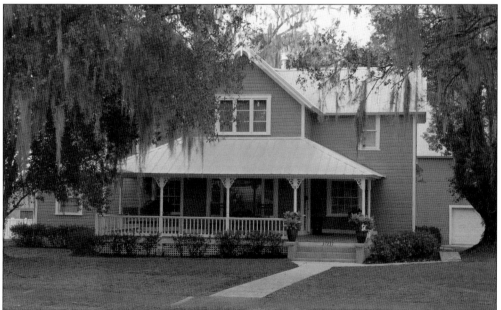

The Hack-Roberts House, between Fifteenth and Sixteenth Streets on Church Avenue, was built in the late 1890s. The Fred Hack family had two somewhat identical homes—this residence, as well as a replica built in Chipco in 1896. They came to the city to escape bugs during certain times of the year. The twin house was the home of Jerry and Myrtle (Burnside) Hunt for many years. (Courtesy of Wise.)

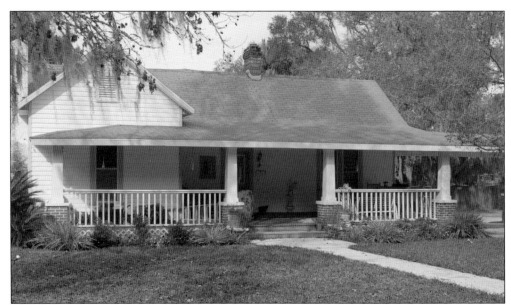

Constructed around 1908 at the northwest corner of Church Avenue and Fifteenth Street in the style of a farmhouse, this house served Eustis and Kate Brown Futch after they married in 1921. Eli Futch, grandfather of Eustus, came to Alachua County about 1840. Eli's son, James T. Futch, operated a commissary at Clark, where Eustus was born in 1894. Jim went into the citrus business in Wauchula, and the family continued in citrus when relocating to Dade City in 1909. (Courtesy of Wise.)

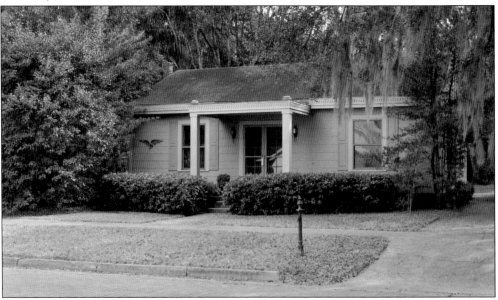

The Gasque house is south of the junction of Church Avenue and Fifteenth Street. Edwin and Lola Gasque were from Florence, South Carolina. They built the Edwinola Hotel along with Edwin's brother-in-law, S.H. Gerowe, who died from a fall from scaffolding while the hotel was under construction. The Edwinola replaced the Dade City Hotel, which burned in 1907. It was a focal point of social life for residents and visitors, with frequent dances and parties. (Courtesy of Wise.)

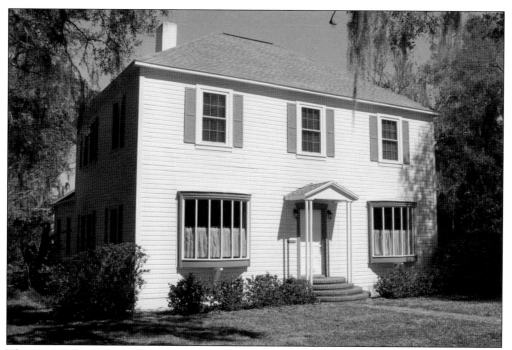

The 1915 Gilbert-Morris home on the northeast corner of Church Avenue and Sixteenth Street was home to M.L. Gilbert and his wife, Levia. He served on the county school board for 12 years before becoming school superintendent. In 1889, he became an ordained minister of the Primitive Baptist Church. He studied law at Clinton College in Kentucky and was associate editor of *Zion's Landmark*, published in Wilson, North Carolina. The Gilberts had seven children and many grandchildren, including Chesterfield Smith, a former president of the American Bar Association. (Courtesy of Wise.)

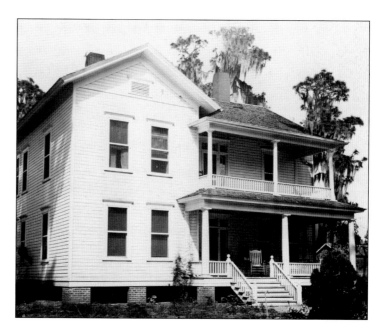

The Simon F. Huckabay residence was demolished, but some remember the Church Avenue house. Huckabay arrived in 1884 and was a merchant. He had three daughters and two sons; one daughter's home (Catherine McIntosh) still stands on the street. Huckabay's IGA Grocery and Huckabay Chevrolet were owned by the Huckabays. (Sparkman Collection.)

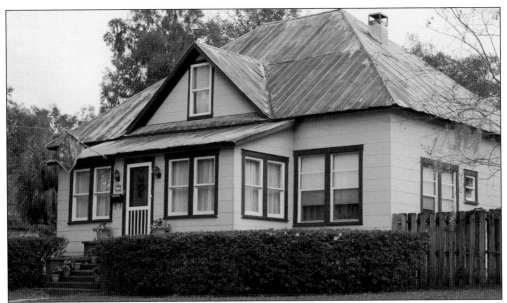

The Jesse Stanley Home, at the southwest corner of Meridian Avenue and Fifteenth Street, was built in 1919. Jesse Stanley was a locally renowned player for the Lacoochee Indians baseball team, sponsored by Cummer Cypress Company in the West Coast League. He was offered a contract with the New York Giants. In 1948, Lacoochee and Dade City teams merged as the Dade City Packers, under Stanley's coaching. A later baseball star was Waylond Eugene Nelson II, a major professional baseball player from 1981 to 1993 with the New York Yankees and Seattle Mariners, for whom Gene Nelson Boulevard is named near John S. Burks Memorial Park. (Courtesy of Wise.)

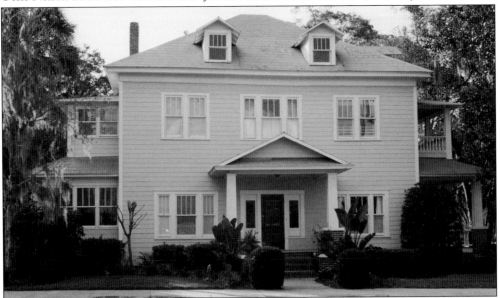

The Mobley House at the southwest corner of Fourteenth Street and Meridian Avenue was built by William L. and Nicie Mobley in the 1890s. It served as a boardinghouse, apartment building, and bed & breakfast. Mobley, a Confederate veteran, was elected Pasco tax collector. His obituary reads, "He was a true Southern gentleman, a man of education, refinement, and culture, and was always ready to lend a helping hand to one less fortunate than he." (Courtesy of Wise.)

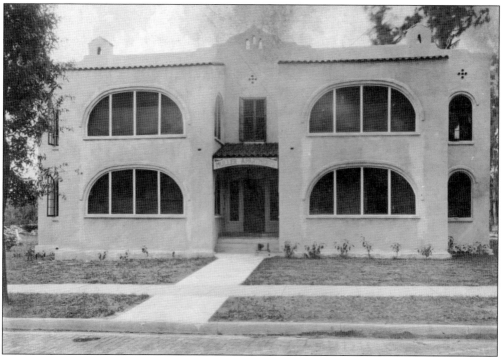

Meridian Apartments (Muller Apartments), at the northwest corner of Meridian Avenue and Thirteenth Street, is an example of 1920s Florida Boom architecture. The apartments were owned by Emile and Agnes Muller. Emile was the supervisor of the City Water Works. (Sparkman Collection.)

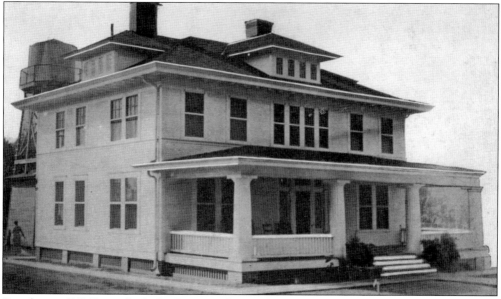

Storekeeper F.S. Daiger built the Daiger-Jackson-Ulmer house in 1910 at the southeast corner of Meridian Avenue and Twelfth Street. Purchased by Dr. Thomas Fred Jackson and his wife, Loral, in 1919, their legacy is Jackson Memorial Hospital. In addition to Daiger and Jackson, the home was also later owned by Judge Ray Ulmer. (Courtesy of Touchton.)

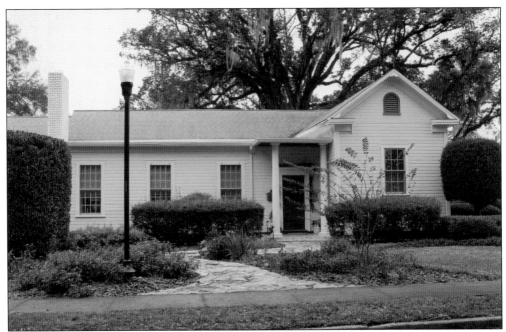

The 1900 Boone-Seay Homestead at the southwest corner of Meridian Avenue and Twelfth Street was built by Alec A. "A.A." Boone. It was later the residence of James Emmett Evans, a founder of Evans Properties Inc. At the age of 21, Evans and his wife, Julia, moved to Florida and began a dynamic citrus career. He created the West Coast Growers Cooperative and organized the Triple-E Development, which acquired citrus groves throughout Florida. (Courtesy of Wise.)

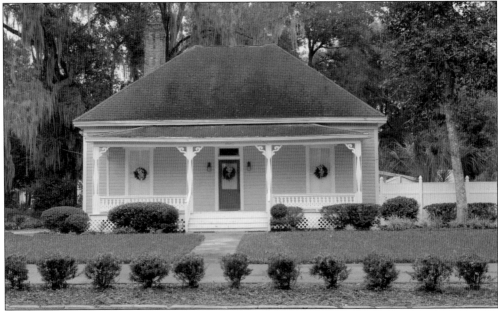

Across from Price Park is the home of D. Walton and Nellie Pinholster, built in 1898 at the southwest corner of Meridian Avenue and Eleventh Street. Price Park is located on the site of the former home of Frank Price and includes tennis courts and brick fencing dating to 1910. (Courtesy of Wise.)

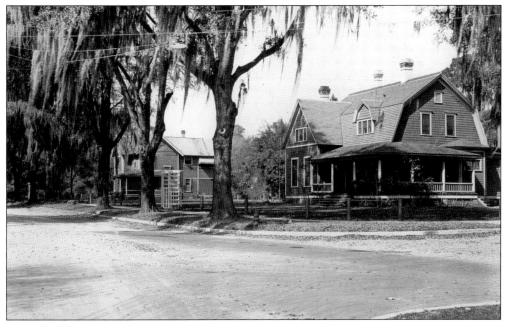

This photograph shows the Hettie B. Spencer home on the northeast corner of Meridian Avenue and Eleventh Street at left and the Lock-Edwards House, formerly the Azalea House Bed & Breakfast, at the northwest corner of Meridian Avenue and Tenth Street at right. Spencer was the postmistress from 1897 to 1936, during which time Christopher A. and Lucy Lock as well as Kitty and Mark Edwards occupied the home at right. (Sparkman Collection.)

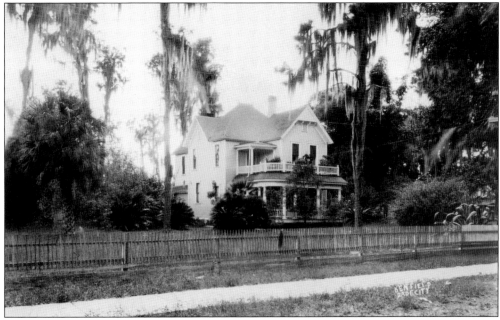

The Ferguson home, dubbed "The Pines," was at the middle of the block between Tenth and Eleventh Streets on Meridian Avenue. In 1902, W.N. Ferguson and his wife, Frances Ella Ferguson, were the owners. Later, it was the home of O.N. Williams and subsequently was converted to Williams Apartments and Regency Townhouses. (Photo by Kenfield, Sparkman Collection.)

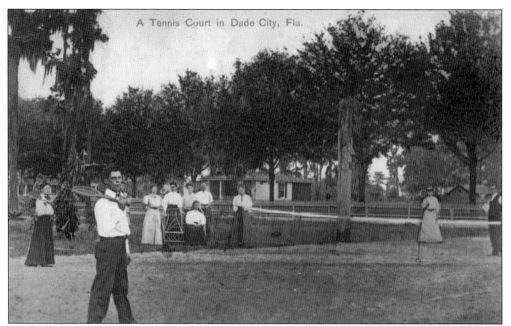

This 1905 postcard shows tennis players at the park on Meridian Avenue. It was developed as a park in 1912. Agnes Lamb's husband, Willard, officiated as mayor in 1968. They were the only husband and wife who served as mayor. Agnes was the first female mayor from 1975 to 1977. (Courtesy of J. Thomas Touchton.)

The Bradshaw-Sistrunk-Jackson-Johnson House, at the northwest corner of Meridian Avenue and Edwinola Way, provided physician/dentist offices. Dr. Bradshaw came to Dade City from San Antonio in the mid-1920s, and in 1919, Dr. Thomas Fred Jackson established a medical practice, along with Dr. Sistrunk. (Courtesy of Miller.)

The Robert Sturkie Home is located at the northeast corner of Meridian Avenue and Tenth Street. He was an attorney and mayor of Dade City and in 1930 was elected to the state legislature. He served in the Spanish-American War and World War I as a lieutenant colonel. Judge Kenneth Barnes also occupied the house. (Courtesy of Wise.)

The Fred W. and Hattie B. Casey House and the Joshua R. & Alicia Brown House sit on Meridian Avenue between Ninth and Tenth Streets. The 1930 census registers the Brown family from Virginia and the Casey family from North Carolina, with homes valued at $2,000 and $4,000 respectively. (Courtesy of Miller.)

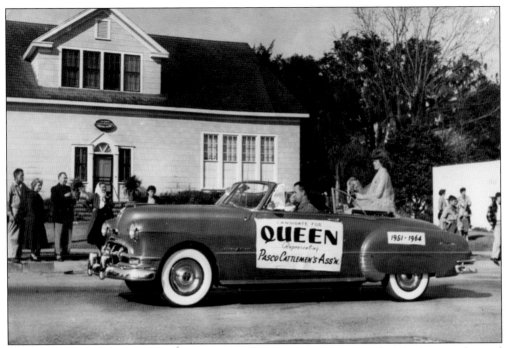

The Cattlemen's Queen in 1964 passes by the Coleman home in a parade. The house is located on Seventh Street and was used as the Coleman & Ferguson Funeral Home for many years. (Courtesy of Pasco Fair Association.)

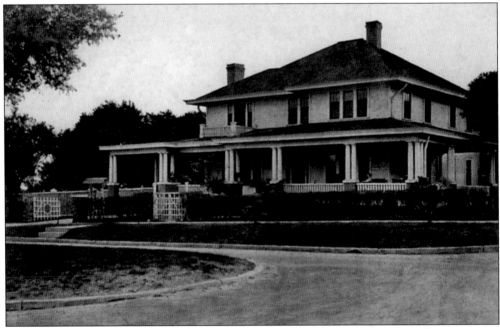

A 1923 *Post* advertisement read, "Touchton's Tourist Home: 2 blocks from courthouse: private baths—rates $1.00 per person, member of National Wayside Homes and Federal Hi-way Homes for Tourists." At the southeast corner of Fifth Street and Meridian Avenue, the site later housed the Tampa Electric Office and the City Hall Annex. (Sparkman Collection.)

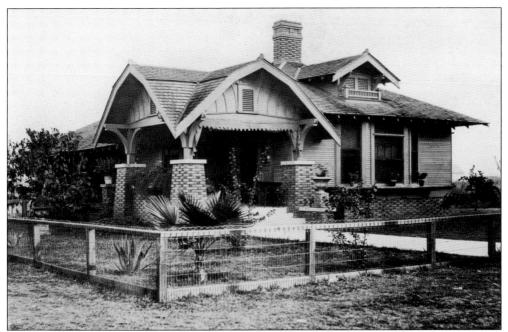

In 1912, James Ambrose "J.A." Peek ordered a Sears Roebuck & Company home kit and assembled it at the southeast corner of Fifth Street and Church Avenue. Peek was mayor of Dade City in 1918. He operated J.A. Peek Feed, Seeds and International Harvester kitchen equipment at the northeast corner of Live Oak Avenue and Eighth Street. (Sparkman Collection.)

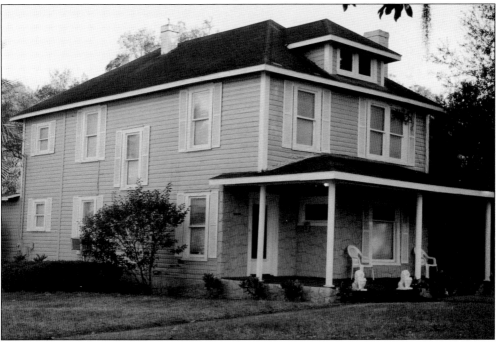

The Roy D. and Clara Guymon family from Illinois built the Victorian-style home on the southeast corner of Fifth Street and Howard Avenue in 1910. It has housed the Milton Funeral Home since 1978. R.D. Guymon operated a Dade City bakery. (Courtesy of Wise)

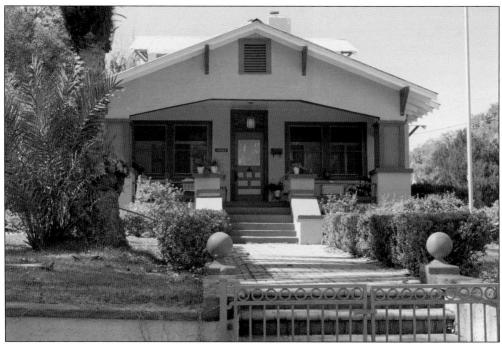

The Mills family built the 1920s residence at the southwest corner of Fifth Street and Howard Avenue in a bungalow style. Drew B. Mills was a proprietor of the Dade City Hotel in the early 1900s. (Courtesy of Wise.)

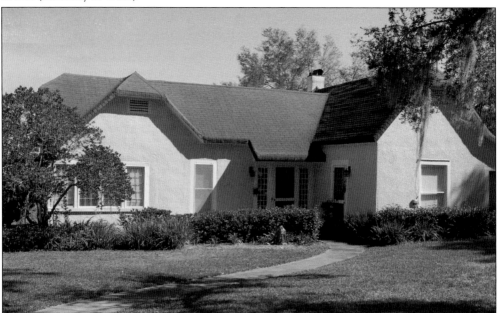

The Cooper-Massey Home at the southeast corner of Fifth Street and Florida Avenue was built around 1894 as a winter home for Gus Cooper. It was a clapboard and framework building. Owners over time have included George and Julia Massey, who purchased the house in 1929 and combined two other houses on the lot to create the current house with a redesigned roofline. (Courtesy of Wise.)

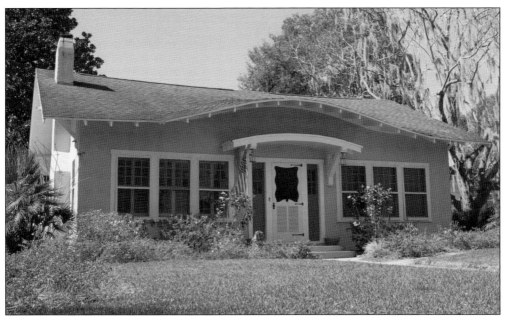

Arthur J. Burnside was the circuit court clerk. His family's home at the northwest corner of Fifth Street and Palm Avenue was built in the 1920s. (Courtesy of Wise.)

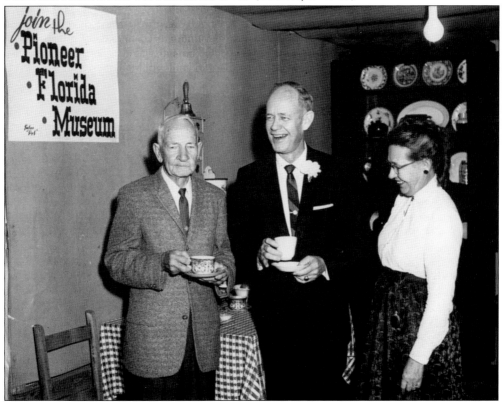

Arthur Burnside (left) hosted Florida governor Ferris Bryant with Carrie Mae Roberts (right) at the inauguration of the Pioneer Florida Museum and Village in January 1962. (Courtesy of Miller.)

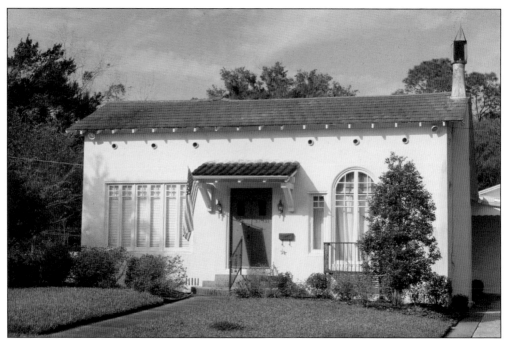

The Bessenger House on Southview Avenue between Fifth and Seventh Streets was constructed in a Cuban-Spanish design in 1925. Following hurricane damage, a pitched roof was installed around 1950. Sheriff Leslie Bessenger and his wife, Pearl Bessenger, bought the house after the Great Depression. Pearl lived in the house for over 70 years. The house faces Hibiscus Park to the south. (Courtesy of Wise.)

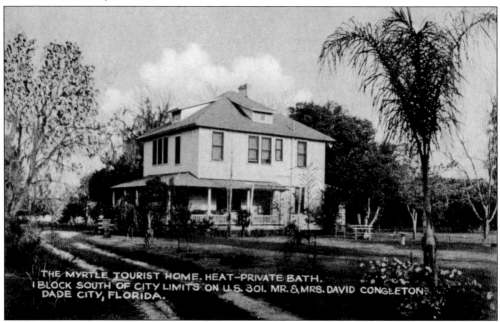

Myrtle Tourist Home, owned by David and Myrtle May Congleton, was located on Highway 301 in the area south of town near where Dr. Chet Taylor's office and Wendy's restaurant now stand. (Sparkman Collection.)

Florida rock was utilized in the 1925 home built by L.M. and Margaret Davis at the southeast corner of Southview Avenue and Eighth Street. A tennis court hints that this was the childhood home of international tennis star Jim Courier. (Courtesy of Wise.)

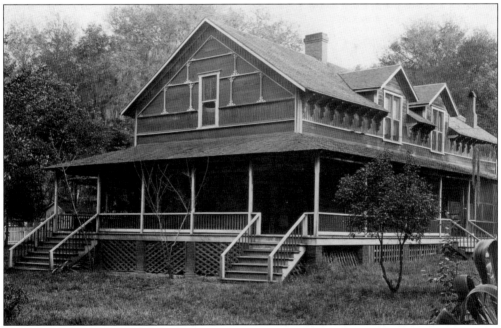

In 1920, this now razed building at the southwest corner of Church and Ninth Avenues became the home of the Dade City Woman's Club. In 1923, the *Tampa Sunday Tribune* labeled it the "Former Woman's Club building." Later, Pasco Theatre and then a bank occupied the site. (Sparkman Collection.)

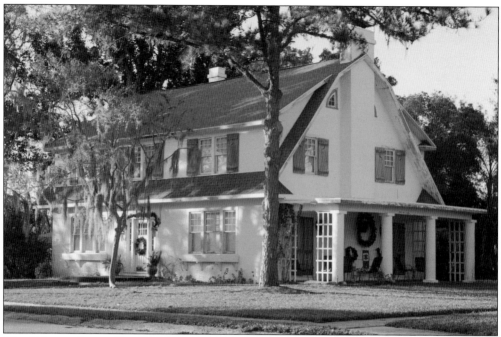

The Gilstrap-Branas Home at the northwest corner of Eighth Street and Coleman Avenue is an early example of a 20th-century residence and has a graceful Dutch-style gambrel roof line. Residents included the Joseph Gilstrap family as well as W.R. and Theresa Branas. (Courtesy of Wise.)

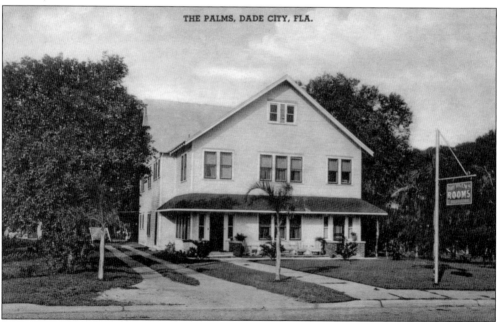

The Woods House on the west side of Seventh Street between Howard and Florida Avenues was originally the Palms, a tourist home later known as the Osceola Tavern. A postcard in 1941 reads, "Modern Tourist Home on Route 23, Dade City, in the heart of the Citrus Belt. Beautifully furnished rooms with or without bath—by the Day, Week or Month." (Courtesy of Fletcher.)

At the southeast corner of Magnolia Avenue and Eleventh Street is the Porter House, built for Laura Spencer Porter, who was a major stockholder in the Bank of Pasco. Also known as the Dorothy Lock House, a plaque affixed to the home reads, "The Dorothy Lock House—dedicated November 8, 1998, given in memory of Julia Burdick Evans by James & Harriett Evans & Margaret Lowry." (Courtesy of Wise.)

Louis Michael "L.M." Eck built the house on Eleventh Street between Magnolia and Robinson Avenues with a hip roof and unusual sash windows. Eck was the proprietor of L.M. Eck Company, known for constructing sidewalks in Dade City and San Antonio. L.M.'s daughter, Helen Eck Sparkman, was a longtime resident of the home. (Courtesy of Wise.)

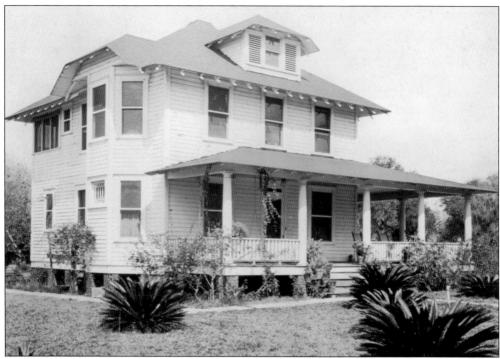

The Howard-Griffin Home, on the northeast corner of Robinson Avenue and Twelfth Street, was built in 1900. The wraparound porch is original to the structure. (Sparkman Collection.)

The Price House on Twelfth Street between Beauchamp and Robinson Avenues was built in 1920. Price was in banking and agriculture. A.F. Price was mayor from 1914 to 1916. (Courtesy of Wise.)

The 1925 home of Frederick D. and Elizabeth J. Cosner, on Twelfth Street at the southwest corner of Robinson Avenue and Thirteenth Street, has been restored by Jay Austin. Cosner was mayor from 1920 to 1924. (Courtesy of Wise.)

The Myers Homestead on the southwest corner of Eleventh Street and Martin Luther King Jr. Boulevard was the home of Lucy T. Myers and was built in 1925. Building materials included glazed, hollow terra-cotta brick. (Courtesy of Wise.)

The John Overstreet House, built in the Civil War era, is a two-story house made of native pine in dogtrot style with three front dormers, characteristic of Cracker farmhouses. It is commonly believed to be the oldest surviving structure in Pasco County. The Overstreet House was donated to the Pioneer Florida Museum and Village and renovated at the museum in 1978. (Courtesy of Miller.)

The Odell Kingston "O.K." Mickens home on Martin Luther King Jr. Boulevard was the residence of the revered educator and was located beside the Christine Hotel, named for Christine Mickens. It was demolished in October 2013. (Sketch by Chad Jones, courtesy of Imani Askukile.)

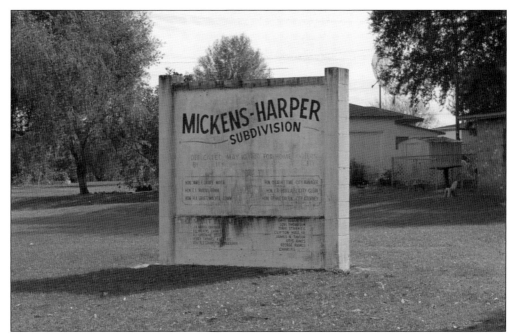

The marker at the historic subdivision for Mickens-Harper was dedicated on May 10, 1949. Committee members included J.R. Harper, O.K. Mickens, H.J. Goodman, Henry Thomas, Rev. A.J. Covington, Ennis Hansberry, Love Thompson, Eddie Starkes, Clifton Hall Sr., James N. Taylor, Otis Jones, George Rawls, and Charles Groom. (Courtesy of Norman Carey.)

James Irvin's homestead is located on First Street. Irvin, a businessman and community role model, was instrumental in assisting with the process of integration. He served as a church deacon, Little League coach/officiator, and Boy Scout leader, and was on the Historical Preservation Advisory Board and was active with many other civic organizations. (Courtesy of Wise.)

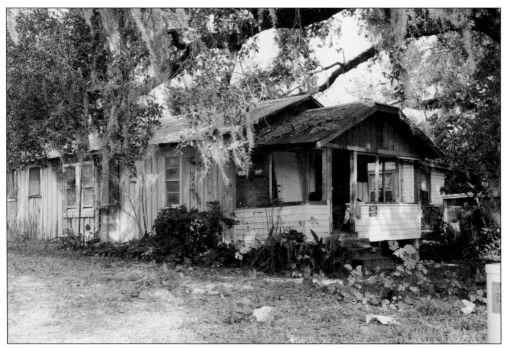

Located on the corner of Tuskeegee Avenue and Railroad Street, Jake Ferguson's home was one of the first African American homesteads. Ferguson built the home in 1922. It is a board-and-batten house built with narrow strips of wood and battens placed over the joints. (Courtesy of Wise.)

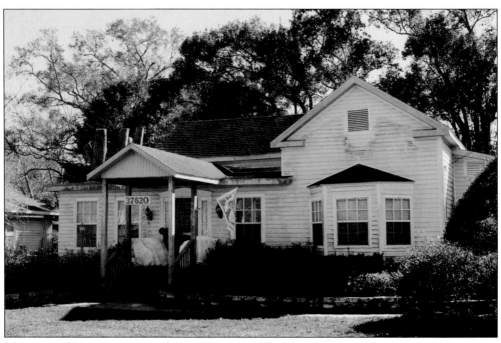

The Howard Home was erected in 1887 in a modified farmhouse style at the southeast corner of Howard Avenue and Twelfth Street. This was the first home in southeastern Dade City. (Courtesy of Wise.)

Three

AMBIANCE AND CHARM

Crossing the old wooden bridge, the railroad sign for the Seaboard Coastline was visible. "People come to Dade City because of the ambiance of a small town. The friendliness of the people here—they speak to you on the streets," said Phil Williams. Extraordinary civic and social groups have evolved over time. Events reflect societal changes. Old-fashioned fun is inherent as well in scenes of community parades, fairs, festivals, and opportunities to kick back and enjoy life. (Pioneer Florida Museum and Village.)

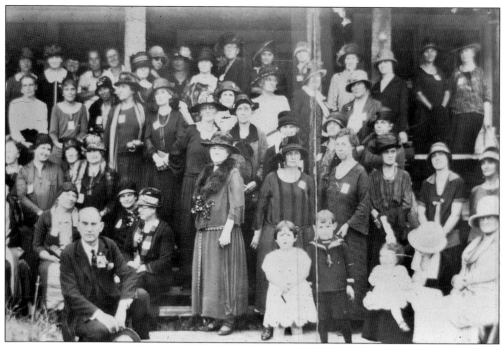

Col. J.A. Hendley, in the foreground, posed with the Woman's Club, which was organized in 1909. Previously called Dade City Board of Trade Auxiliary, Ruth Polly Touchton wrote, "These women did much good for the betterment of the community." They had various meeting locations over time, including the Dade City Hotel Sample Room, O.L. Dayton's home, and their present location in what was referred to as Congress Park. (Courtesy of A.D. Jernigan)

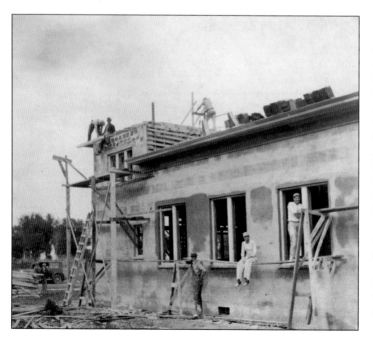

Shown under construction, Dade City Woman's Club is located on Palm Avenue. The building was completed in 1926 on land donated by I.M. Austin with a meeting hall, stage, and dining area. Members raised $23,000 for construction. Sallie Embry was the 1910 charter president and later, Dollie Hendley served as president for 17 years. The clubhouse has hosted recitals, wedding receptions, debates, and much more. (Courtesy of Miller.)

In the Highlands of Dade City, Fla.

Frederick Cook made a speaking stop in Dade City on March 13, 1914, to report on his discovery of the North Pole. There continues to be controversy as to whether Robert Peary or Cook was first to reach it. (Courtesy of Miller.)

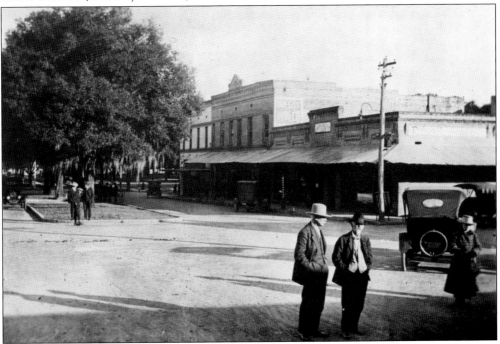

This 1914 photograph conveys a sense of community. Two fellows are chatting in downtown Dade City. One wonders what they might have been discussing. Some news tidbits of 1914 included a new newspaper, *Dade City Banner*, with John Tippen as editor; dedication of Saint Rita Church; and the opening of a packing plant by J.T. Futch. (Courtesy of Florida Department of State.)

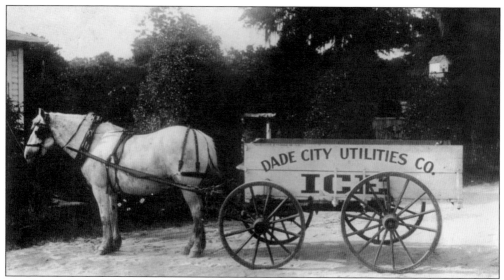

This beautiful Percheron draft horse toiled for Dade City Utilities Company and later pulled the hearse for Coleman & Ferguson. The Pioneer Florida Museum and Village displays this photograph with a caption stating that the horse had great instincts: "When he got himself loosened from the city hitching post, he would walk home to his barn." (Courtesy of Pioneer Florida Museum and Village.)

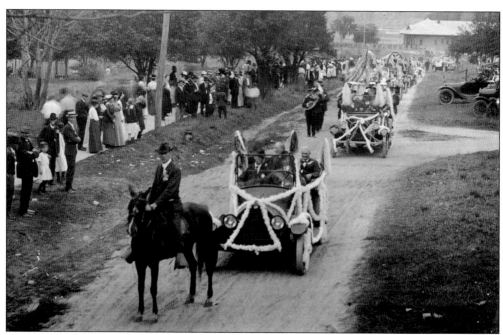

Parades such as this one in 1917 are a traditional part of Dade City culture. The spring Pasco County Fair dates to 1915 and the Christmas Parade to 1982. (Courtesy of Miller.)

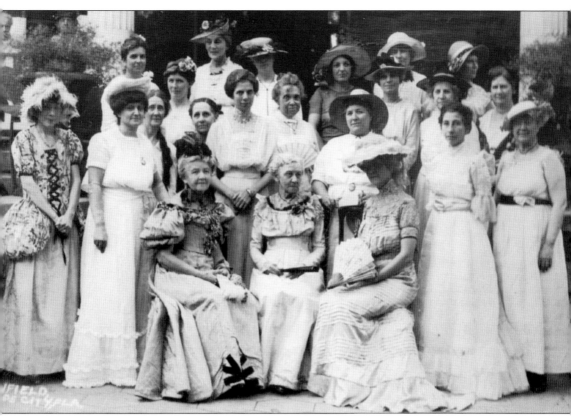

The Alpha Sorosis Club was organized by Dade City women in 1909 and continued through 1968. They met regularly for intellectual pursuits. This 1928 meeting at the Edwinola Hotel marked the organization's anniversary. Each member dressed in teenage attire and answered to roll call from the latest book they had read. This photograph includes Mrs. H.O. Aughenbaugh, Mrs. Walter Balyeat, Jane Butts, Mrs. Elwyn Butts, Sarah Carter, Mrs. Ray Cook, Mrs. T.B. Forsburg, Emily Grace Clark, Nancy Davis, Minnie Dayton, Harriet Gardner, Mrs. P.H. Hill, Mrs. W.R. Packer, Mrs. Waldo Richardson, Frances Sistrunk, Mrs. E.L. Stevenson, Mrs. R.B. Sturkie, Mrs. C.R. Taylor, Mrs. H.W. Willis, Mrs. M.C. Wood; Miss F.C. Wirt, and Mrs. F.C. Ziegler. (Courtesy of Susan Maesen.)

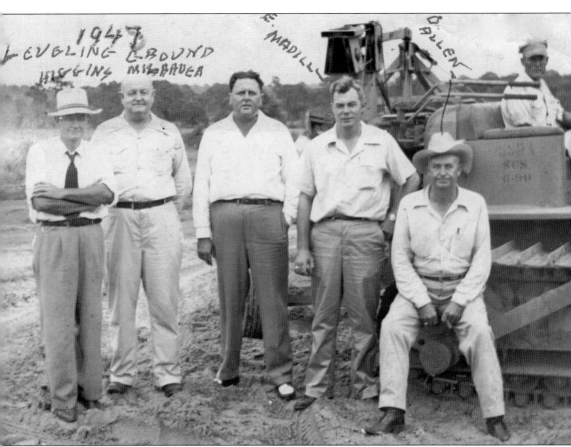

In 1947, Dan E. Cannon, Jimmy Higgins, George Nikolai, Bob Williams, and Joe Collura met to identify a county fair site. A 40-acre plot along State Road 52—west of town—seemed ideal, and they proceeded to raise the needed $3,500. In 1947, the Pasco County Fair Association Inc. was chartered. Breaking ground in the photograph were Higgins, M.L. Milbauer, D.E. Cannon Jr., Ed Madill, and Oscar Allen. Other 1947–1948 board members included N.M. Swartsel, Hazel Whitman, W.R. Gould, Marianne Simons, Joe Herrmann, A.H. Schrader Sr., and Mrs. F.C. Wirt. (Courtesy of Pasco County Fair Association.)

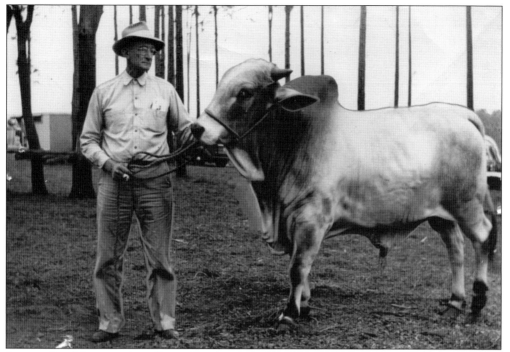

Jeanette Barthle penned a colloquial book entitled *Cowboys, Kids & Critters* in 1994 with tales of country life. The Barthle Brothers Ranch, originally about 20,000 acres, continues as a state-of-the art cattle operation. This 1948 photograph depicts J.A. Barthle with a Brahman bull. (Courtesy of Pasco County Fair Association.)

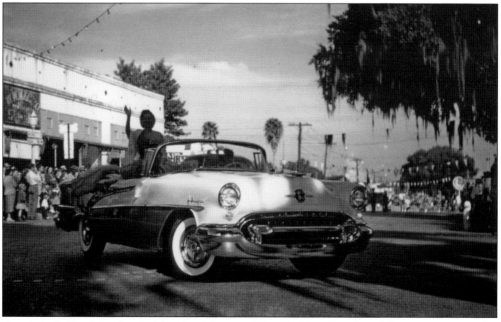

Ann Gloria Daniel, a local girl, gained fame as Miss Florida of 1954, and first runner-up in the Miss America pageant. In the 1955 Fair parade, she appeared in a shiny 1955 Oldsmobile at the intersection of Seventh Street and Meridian Avenue. (Courtesy of Norman Carey.)

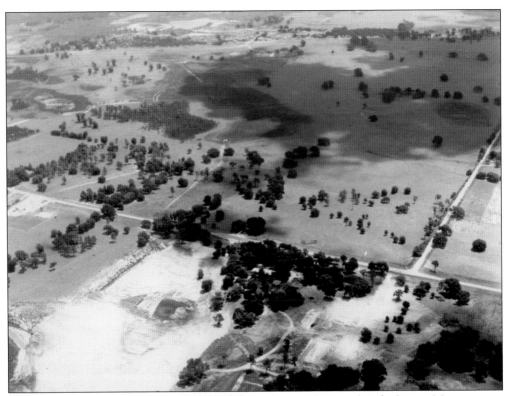

An aerial view of Dade City in May 1957 shows open land, meandering roads, and trees. (Photograph by Burgert Brothers, courtesy of Tampa-Hillsborough Public Library System.)

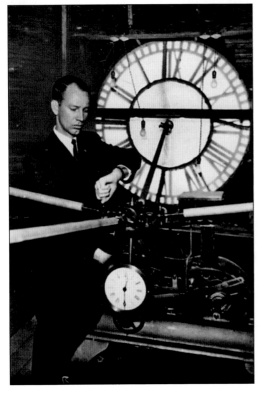

Stanley Burnside, clerk of the Circuit Court, adjusts the courthouse clock on June 5, 1960. The clock was manufactured by E. Howard Watch & Clock of Boston. Phil Wright, from the Howard Clock Company in Ohio, refurbished the vintage clock in 2001. (Courtesy of *St. Petersburg Times*.)

Sally Blackwood's Dance Studio has been an icon for over 49 years. Sally recently received the coveted Paul Harris Fellow from Rotary International to honor 49 years of dance instruction in the community. This 1969 photograph depicts, from left to right, dancers Helen Walters, Lisa Abraham, Jane Huckabay, and Lois Henry in the Central Florida Ballet Company. Sally said proudly, "Helen went on to be a soloist with Agnes DeMille's Dance Company, while Lois was director of dance at Saint Leo College, and Lisa danced for North Carolina School of Arts." (Courtesy of Sally Blackwood.)

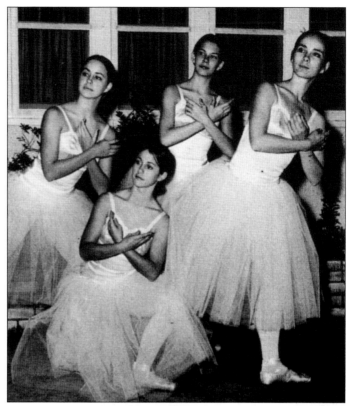

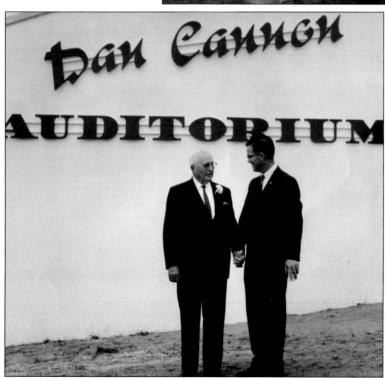

Dan Cannon and Luther L. Rozar Jr. stand in front of the Dan Cannon Auditorium at the fairgrounds for its dedication. Other dedicated fair buildings include the Albert Barthle Livestock Pavilion, E. Madill Building, A.H. Schrader Building, Collie Clayton Hall, Joe Collura Building with F.J. Collura Back Porch, Jimmy Higgins Building, Joe Herrmann Greenhouse, and Cutler Brothers Building. (Courtesy of Pasco County Fair Association.)

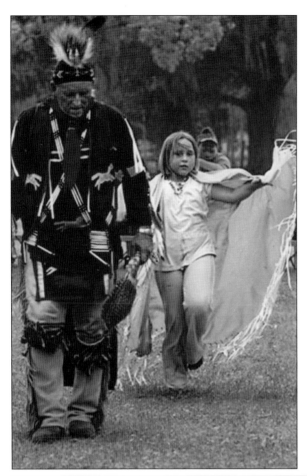

Withlacoochee River Park, with the Pasco County Parks and Recreation, has sponsored the Mother's Day Powwow, a hands-on exhibit showcasing Native American culture. Exhibits include conservation, native dance, storytelling, and history. Here, Herb Shepherd dances alongside Megan Lorenzo in 2007. (Photograph by Lance Rothstein, courtesy of *Tampa Bay Times*.)

The centennial was marked with a remarkable parade in 1976. Dade City was the cultural center in the 19th and early 20th centuries, sparkling with the latest fashions and trends. (Courtesy of the Florida Department of State.)

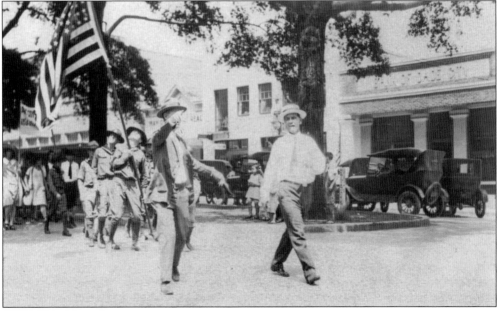

One of the last divided brick streets in Dade City is Howard Avenue between Fifth and Seventh Streets. It is representative of the abundant brick streets that once adorned the city. The bricks, which provide the foundation for much of Dade City, were manufactured by Southern Clay Manufacturing of Robbins, Tennessee. Its brick was sold to markets including Chattanooga, Miami, Jacksonville, and St. Augustine. The company was prominent in the industry until 1937. (Courtesy of Wise.)

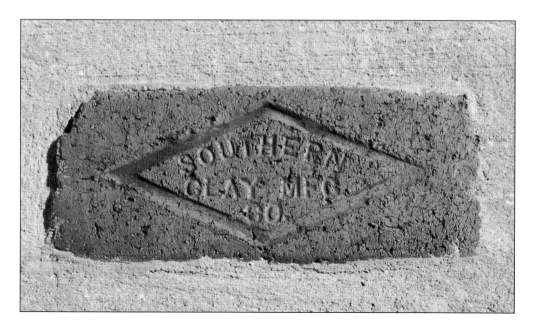

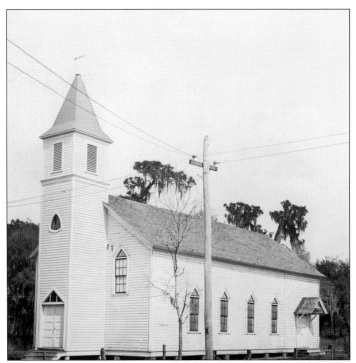

Former St. Rita Catholic Church (now at Fifth Street, south of Southview Avenue) was a pioneer-style structure built in 1913. The building was sold to the Garden Club in 1976 for $1 and relocated. "The electric power company was involved and took down telephone poles and electric poles so the church could make the slow trek," said Helen Helseth. (Pasco Board of County Commissioner's Historical Preservation Committee.)

The Garden Club introduced landmark historical ornaments in 1994. Ornaments commemorate Pasco County Courthouse, Dade City Grammar School, Garden Club, First Presbyterian Church, Woman's Club, Pioneer Florida Museum and Village, Edwinola Hotel, St. Mary's Episcopal Church, Saint Leo Abbey, First Methodist Church, National Guard Armory, Atlantic Coastline Railroad depot, First Baptist Church, Williams/Lunch on Limoges, Lacoochee School, Pasco Packing Association, the World War I Memorial, and Pasco High School buildings. (Courtesy of Diane Scott.)

This photograph from an early 1960s Christmas parade shows Crest Restaurant at left. Carol Jeffares said of the Crest Restaurant, operated by Earl Fitzgerald, "On a given day, you might find an attorney dressed in a three-piece suit on break from a trial sitting next to a truck mechanic, while enjoying a home-cooked meal." The corner eatery was built in 1920 by Harry Neal and was first called Shop Perfect and Shofner's Restaurant, then Hevia's Restaurant, and other names. The site is now occupied by Lori Anne's Gifts. (Courtesy of Pasco County Fair Association.)

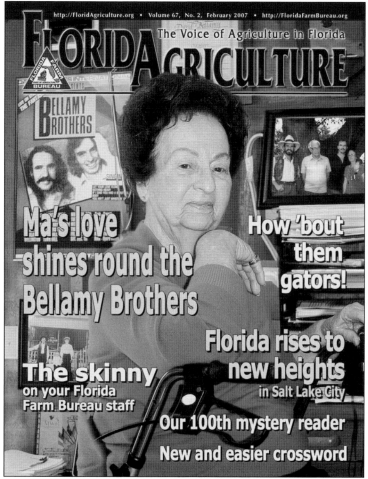

Frances Bellamy of Darby appeared on the cover of *Florida Agriculture* magazine in February 2007. Retired from Pasco County Schools, Frances is the mother of Howard and David Bellamy, renowned for their famed country music. The duo regularly participates in concerts, hometown events, and public relations for their hometown community. (Courtesy/permission of *Florida Agriculture* magazine, Florida Farm Bureau publication.)

The African American Heritage Society of East Pasco presents the Carter G. Woodson awards annually to outstanding leaders during Black History Month. Here Imani Asukile presents the award to artist James K. Farmer in Dade City. Others who have been recognized include Dr. Robert Judson, James Grant, Marie Brown, Theresa Pressley, Ruth Black, and Asukile. (Courtesy of Wise.)

Dade City commissioners are pictured here at the 1989 centennial. From left to right are Agnes Lamb, Fred Johnson, Patricia Weaver, Bill Dennis, and Col. Charles McIntosh, mayor. The centennial included a week of activities sponsored by the chamber of commerce. Pasco County's centennial was commemorated two years earlier in 1987. (Courtesy of Black.)

Four

THE FOLKS OF DADE CITY OVER TIME

People make up communities, and the thousands of folks who have occupied Dade City and surrounding areas over the centuries represent a diverse and hardworking group. Col. Jefferson Alexis "J.A." Hendley migrated to Florida in 1881 by mule-drawn wagon, like so many others. Elected county surveyor of Hernando County in 1883 (then comprised of Hernando, Pasco, and Citrus), he was elected to the state senate in 1885. Appointed to the Florida Constitutional Convention, he was the youngest member. When honored by the 1940 Florida legislature, Judge Hendley said, "My message to you is to stand by the constitution of our great state." (Photograph by Burgert Brothers, courtesy of Tampa-Hillsborough Public Library.)

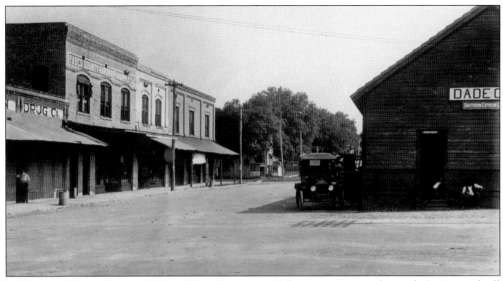

In *History of Pasco County*, Colonel Hendley wrote, "I do not own a ranch nor do I raise and sell fine stock which roam over large pasture lands, but I have been energetic and made great effort to build up Pasco County. I think it is now the banner county in both fruit and vegetables. We had a great fight to wrest the state from under carpetbag rule (1886). Dr. Richard Bankston and I went to Tallahassee and succeeded in getting the county divided by an act of the legislature . . . Reuben Wilson, H.W. Coleman and I secured the rights of way in order to get the two railroads into Dade City." (Courtesy of Dayton.)

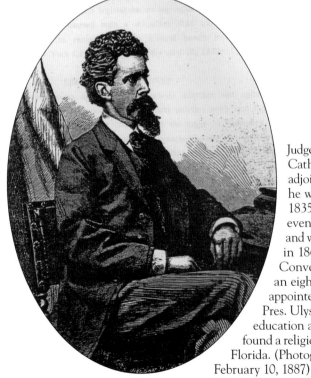

Judge Edmund Francis Dunne founded the Catholic Colony of San Antonio, Florida, adjoining Dade City. A charismatic fellow, he was born in Little Falls, New York, in 1835. He journeyed to California and eventually studied law in San Francisco and was elected to the California legislature in 1862. He served in the Constitutional Convention for Nevada in 1864 and was an eight-term member of its judiciary. Later appointed chief justice of Arizona Territory by Pres. Ulysses S. Grant, he had strong views on education and religion. He eventually sought to found a religious colony and handpicked the site in Florida. (Photograph from *McGee Illustrated Weekly*, February 10, 1887)

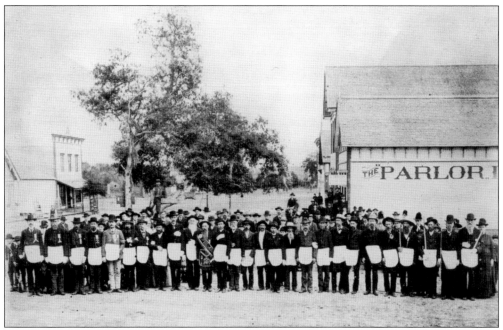

One of the oldest photographs of Dade City, taken on May 25, 1889, displays members of the Masonic Lodge from Mount Zion who met here. Many also helped establish the Trilby Lodge No. 141. The Bank of Pasco, chartered in 1889, is under construction in the left center background. (Courtesy of Dayton)

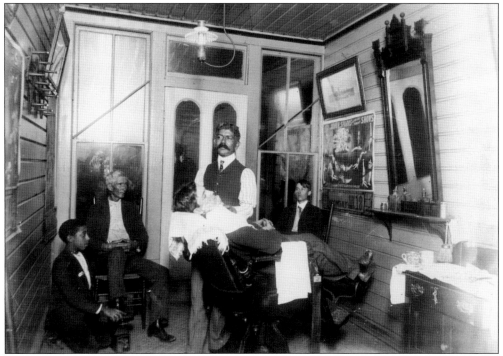

The poster on the wall advertises a circus in Dade City for January 18, 1904. The young man is Henry Harper. (Photograph by Winnifred Bridge; Sparkman Collection.)

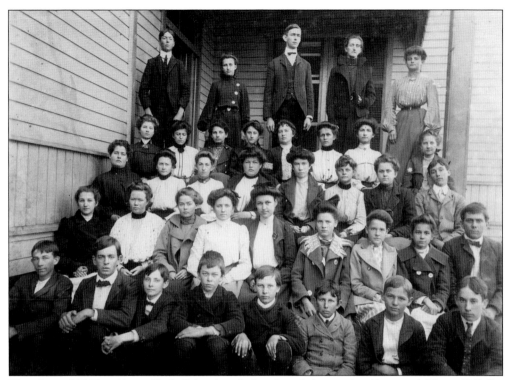

The class of 1905 at Pasco High School includes, from left to right, (first row) Harry Hill, Ira Soar, unidentified, Glenn Sumner, James Dormany, John Embry, and George Heath; (second row) Gertrude Osburn, Omah Hays, Oma Geiger, Annie Tait, May Ferman, Peachy Henley, Mabel Carroll, Janette Seay, and John Sumner; (third row) Margery Geiger, May Tait, Love McMahon, Maoma Hill, Jewell Altmond, Willie Bachelor, Ruth Sumner, and Willie Bigger; (fourth row) Mignon Geiger, Bonnybelle Shofner, May Burkett, Trudy Taylor, Amy Guyman, Lucy Batchelor, Jessie Ray, and unidentified; (fifth row) William Stephens, Maud Osburn, W.E. Everett (principal), Ella Osburn, and Lula Burkett. (Courtesy of Inez L. Knapp.)

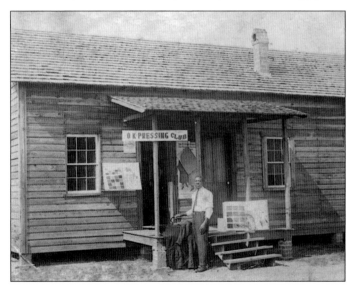

Wheeler Herman Bennett operated the OK Pressing Club on the west side of Seventh Street, just one block south of Martin Luther King Jr. Boulevard. The building was clustered among several commercial buildings called Red Row. Bennett was also an AME pastor and labored with churches at Croom and Oldsmar, among others. He was the husband of Grace Bennett and father of Cora Lee Bennett. (Courtesy of Black.)

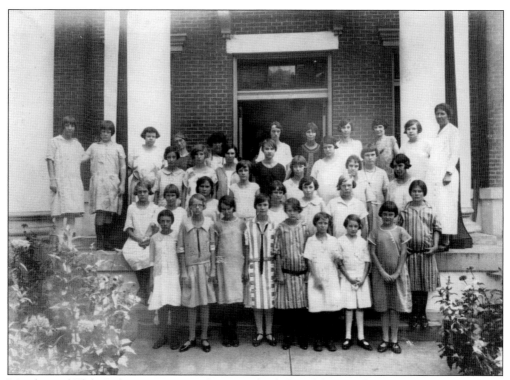

Members of Club Girls participate in the annual exhibit of their work in 1925. Harriet Ticknor, in front of the right pillar, is shown with girls of her clubs in Pasco County. Identified names are Dorothy Lynch, Monica Ullrich, Virginia Boyce, Carolyn Boyce, Sarah Mahoney, Mary Dunne, Esther Abraham (Lorise's mother), Ila O'Berry, Helen Voorhees, Ruth Davis, and Frances Kovarik. (Sparkman Collection.).

In 1949, youth exhibitors pose with their poultry cages downtown in front of the county courthouse. Louis Mims reported that he ordered the Rhode Island Red chicks from the Sears & Roebuck catalogue and they arrived via train in a paper box. Shown here are, from left to right, (first row) Mack Anderton, Dennis Harvey, Howard Lay, Aaron Mitchell, and John Wichers; (second row) Louis Mims, David King, Wayne Gude, county agent/4-H leader Jimmy Higgins, and Charley Gordon. (Courtesy of Pasco County Fair Association.)

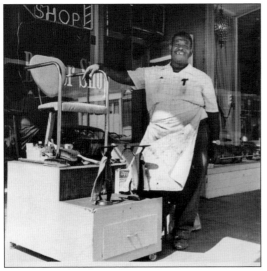

One of Dade City's oldest continuing businesses on Seventh Street, Max Ray Arnold, known as "Big Mac," shined shoes in barbershops from the age of 15. African American sons and daughters have contributed to the community and made their mark in the world. Baseball's James Timothy "Mudcat" Grant played for the Cleveland Indians, Minnesota Twins, and Los Angeles Dodgers. Opera star Janette Thompson, who made her Carnegie Hall debut performing Verdi's "Messa da Requiem," is an international star who returned to Florida to sing at Gov. Bob Graham's inauguration (Courtesy of *St. Petersburg Times*.)

Pasco High School's class of 1916 with their pendant included, from left to right, (first row) Sally Brown, Hettie Huckabay, Molly Tucker, Clemnie Croft, and Ruth Davis; (second row) Frank Ingram, Van Ness Cole, Sewell Haward, Dewey Hudson, and Ralph Coleman. Dr. Mary Giella commented, "For many years, Pasco County government and schools were led by Pasco High School graduates. Many from Pasco High School and Mickens High School went on to have distinguished careers." (Courtesy of Miller.)

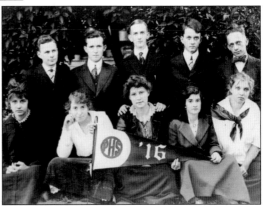

An annual rally of 4-H clubs was held in Dade City in April 1927. Young people attending included Sherhan Rice, Lynley McCarty, Pat Nathe, Ray Hays, Leslie Sullivan, Tom Prator, Shelton McKinney, Carl Vorhes, Mitchell Drew, Emmanuel Osburn, Arthur Connell, Copeley Davis, and W.S. Larkin. (Sparkman Collection.)

Julie Obenreder wrote for the *Pasco Centennial*, "Doctors were few and far between and their knowledge left much to be desired in the era of early settlement. Diseases, such as typhoid fever, scarlet fever, pneumonia or appendicitis, meant almost certain death. Fractured bones were usually pulled back into place by a member of the family, often leaving a person with a crippled or even useless limb for life. Babies were delivered by 'Grandma' or a neighborly midwife. Home remedies prevailed." Here, Dr. T.F. Jackson poses in Dade City. (Sparkman Collection.)

Main Street Cleaners was owned by brothers-in-law George Rawls and James Irvin. Their wives were Maggie Thompson Rawls and Lucille Thompson Irvin. Known for extraordinary customer service, both couples were involved in day-to-day operations from its opening in 1945. (Courtesy of Wise.)

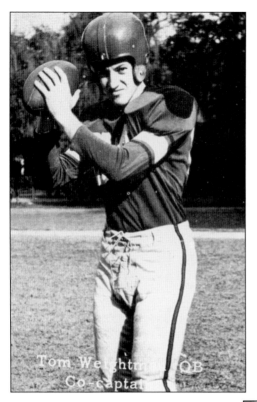

Thomas E. Weightman, a native son, quarterbacked the 1953 Pasco High School team and earned scholarships to Stetson and Florida State University. He served for 22 years as the Pasco County school superintendent, through phenomenal population growth. In 2012, he said, "The most important thing that any government at any level can do is to take care of the needs of children." (Courtesy of Miller.)

Named to the Florida Civil Rights Hall of Fame in 2012 by the Florida Commission on Human Relations and the 2010 Hispanic Woman of the Year, Margarita Romo, founder of Farmworkers Self-Help Inc., has worked diligently for 40-plus years for migrant families in the community. Governor Scott said, "She has acted on her conviction and truly made a difference in countless lives in our state and around the country." (Photograph by Davida Johns, courtesy of Farmworkers Self-Help Inc.)

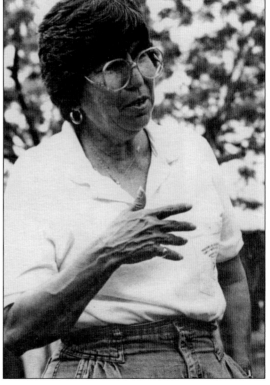

Odell Kingston "OK" Mickens, principal of Mickens High School, poses with his faculty in the late 1950s. From left to right are (first row) Irene Rogers, Willie B. Silas, O.K. Mickens, and unidentified; (second row) Christine Mickens, Claudia Lewis, unidentified, and Thelma Yarn; (third row) Mike Ardis, Arrewintha Campbell, Louise Gilbert, Matthew Evans, Professor Walter J. Young Jr., and Mozelle Ford; (fourth row) Thelma Thomas, Martha Lewis, Mary Marshall, Allie D. Penix, Cora E. Hill, and Hiram Goodwin; (fifth row) unidentified, Melvin Dennard, Dorothy Trammer, Hayes Howard, and unidentified. (Courtesy of Leslie J. Ruttle.)

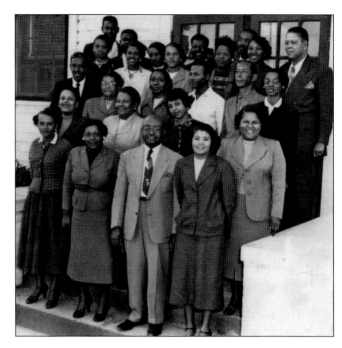

Long distance telephone dialing for Dade City began in July 1967, with the mayor making the first direct long-distance call. With 5,500 subscribers from a dozen Pasco and Hernando County communities, they were proud of the technology. The call was to US representative A. Sydney Herlong Jr. in Washington, DC. Taking part were, from left to right, (sitting) manager Max E. Wettstein and Mayor Charles F. Touchton Jr.; (standing) Pasco commission chair Archie E. Storch of San Antonio and Mayor A.O. Kiefer of Saint Leo. (Photograph by Shirley Chestain, courtesy of *St. Petersburg Times.*)

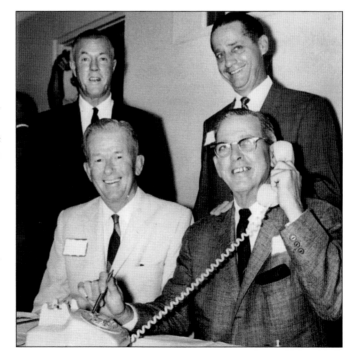

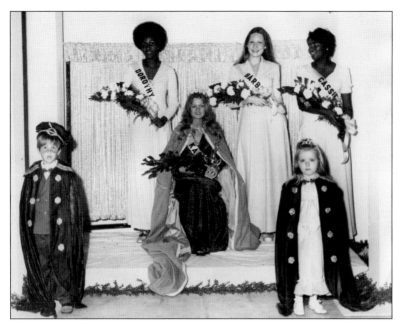

Pasco County pageant winners in 1974 were, from left to right (first row), Jeffrey Thompson and Lisa Perkins, junior court; (second row) Dorothy Standifer, Karen Milton, Barbara Badtram, and Cassie Coleman. (Courtesy of Pasco County Fair Association.)

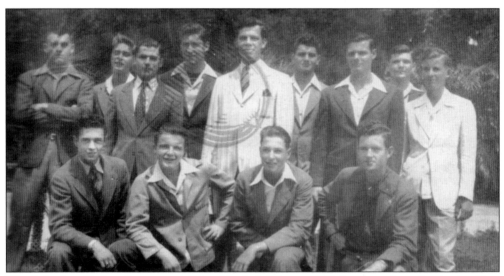

The Saint Leo College Preparatory School included future 1965 Academy Award–winning Best Actor Lee Marvin. Juniors in 1942 included, from left to right, (first row) Robert Rooney, Jack Carr, Joseph Barthle, and Arthur Edge; (second row) Robert Bargar, William Korchak, Theodore Zywocinski, William Livingston, Lee Marvin, Robespierre Pardo, Richard Ahearn, Patrick Burns, and William Buesching. Classmate Charles Gilbert is not pictured. Marvin was a member of the L Club, an organization for male athletes who earned a major award in sports. "The Lions broke seven records . . . Lee Marvin copped the low and high hurdles and the javelin throw to garner 15 points in 1942." He was a member of the dramatics club and starred as Solomon in the production of *The Brother Orchid* by Richard Connell. (Photograph by *The Lion Annual*, Saint Leo College Preparatory School, courtesy of Saint Leo University.)

Five

THE ECONOMY

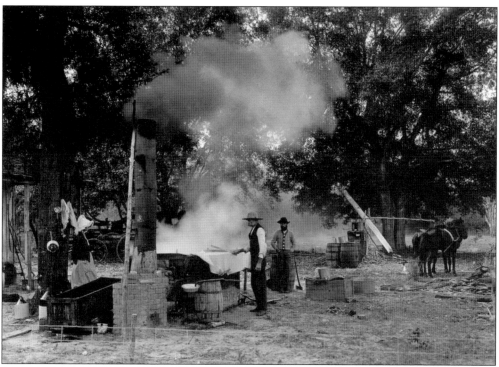

Glimpses of the economic and business forces that shaped Dade City are provided in the following chapter. Dade City has undergone several metamorphoses over time. As a strong agricultural community dependent upon timber, sugar cane, free-range cattle, and poultry, the area retains its agricultural roots but also offers a service focus. This photograph shows syrup making with the boiling vat and a mule in the background. Sugar syrup was treated almost like money, selling for $1 a gallon; 50 gallons of syrup could be traded for a horse. (Photograph by Burgert Brothers, courtesy of Hillsborough Public Library.)

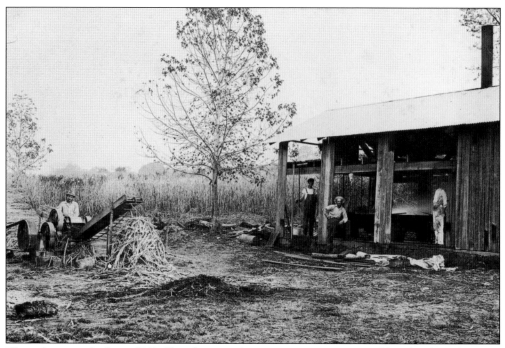

This photograph shows E.S. Slough at work processing sugar cane. Slough's San Antonio Sugar Mill was purchased by the State of Florida to make cane syrup for state-owned facilities. (Sparkman Collection.)

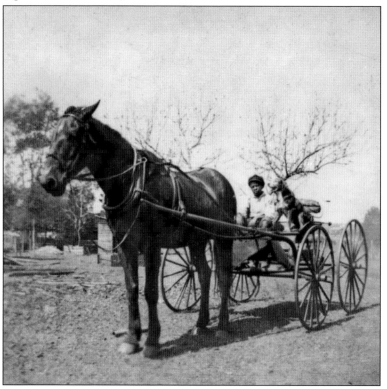

A young man drives a handsome horse and buggy in the early 1900s. African Americans did much of the labor on the burgeoning rails that were laid into Dade City, and had a significant impact on the economy as workers. (Courtesy of Dayton.)

The 1911 telephone booklet lists two livery stables: R.L. Seay's Livery & Feed Stable and Brown's Livery & Feed Service. The Seay Livery had a variety of painted advertisements proclaiming the upcoming "Virginia Traveling Colored Minstrel Show." (Courtesy of the Pioneer Florida Museum and Village.)

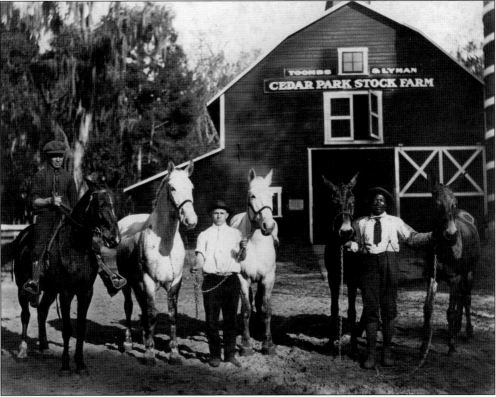

Toombs & Lyman Cedar Park Stock Farm was essential for agrarian businesses and households. This postcard, dated 1925, includes Cliffton Gilbert, Rex Gilbert, and John Peterson. (Courtesy of Miller.)

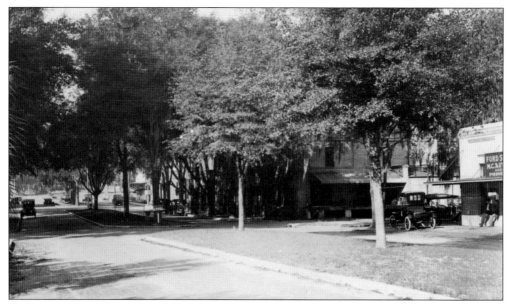

At Meridian Avenue and Sixth Street, the Sunny Brook Tobacco office and warehouse was built in 1908. Founded by W.E. Embry, who migrated from Kentucky in 1897, it was a viable economic asset until 1989. The company contracted for approximately 100 acres of shade-grown Havana and Sumatra tobacco. In later years, the structure was known as the Massey Building and was torn down in 1989. This photograph shows Sunnybrook in relation to the Ford Shop. (Courtesy of Miller.)

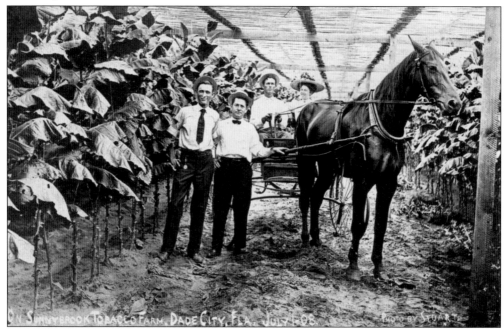

The horse tobacco rig at Sunnybrook Tobacco Farm on July 1, 1908, showcases the covered growing houses. Rosenfeld, president, purchased the operation from Wallace Embry in 1908. According to Eddie Herrmann, this company was the largest Pasco County employer from 1908 to 1923. (Courtesy of Miller.)

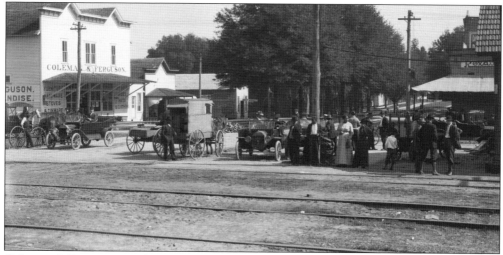

Coleman & Ferguson was the oldest mercantile business when it closed in 1938. "Tin can tourists frequented Dade City and attended annual meetings at the community hall, now site of the Armory," Helen Sparkman said in a presentation to the Pasco County Historical Society. "I do not know if they were called 'Tin Lizzies' because of their vehicles or food they brought in tin cans." (Courtesy Florida Department of State.)

A 1930s building at the junction of Tenth Street and Sumner Avenue was built of native limestone rock. This location served as the site of the Pasco County Fair during the late 1930s. J. Willard Lamb managed the Farmer's Market from 1949 to 1952. The Lambs operated the egg market in the building until 1968. Willard officiated as mayor in 1968 while Agnes served from 1975 to 1977. Mayor Camille Hernandez continues the tradition of service in 2014. (Courtesy of Wise.)

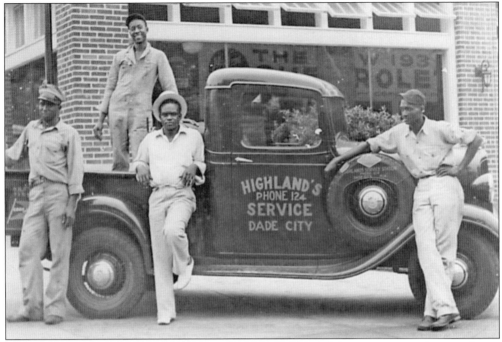

Workers line up by one of the service trucks from Highlands Motor, posing in their uniforms. Thelma Touchton wrote that other merchants included "Pasco Abstract Co. with the Locke family; Treiber and Otto Hardware; Madill, hardware and furniture; R.D. Guymon and Harry Tipton, bakeries; Covington, Gruetzmacher, Burks, and Butler, automobile dealerships." (Courtesy of Herrmann.)

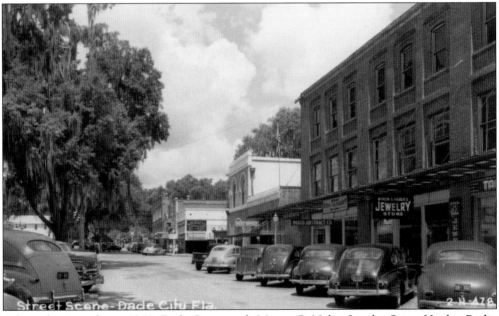

A busy shopping day in 1940s Dade City reveals Myron G. Naber Jewelry Store, Hooker Radio & Television Company, Pasco Abstract Company, Margaret Davis Beauty Shop, the post office, W.W. McClung's 5 & 10, and Varn's Shoe Store. (Courtesy of Touchton.)

Ramona Zarate, a farm laborer, lived in the area for over 39 years. Her living quarters were on a hill northwest of town where Tim Burton's movie *Edward Scissorhands* was filmed with Johnny Depp in 1990. With five children, Ramona picked oranges every day during the season, as did many farm workers in the area. (Photograph by Davida Johns, courtesy of Farmworker's Self-Help Inc.)

Farmworker's Self-Help Inc., originally named *Santuario* (sanctuary), was organized in 1979 and incorporated in 1982. It is in Tommytown, a 1940s development built by Tommy Barfield on Lock Street to accommodate migrant Hispanic workers for Pasco Packing. When the plant closed, the area dealt with unemployment. Lock Street was recently renamed *Calle de Milagros*, (Street of Miracles) by the Pasco County Commission. (Courtesy of Farmworker's Self-Help Inc.)

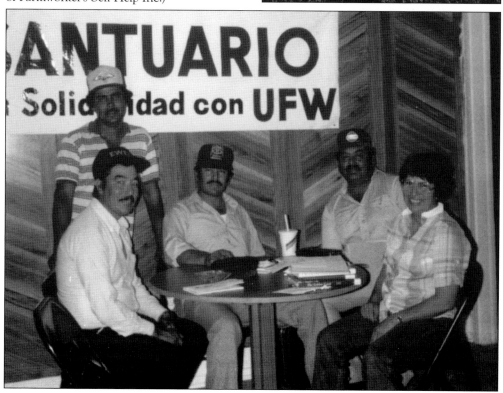

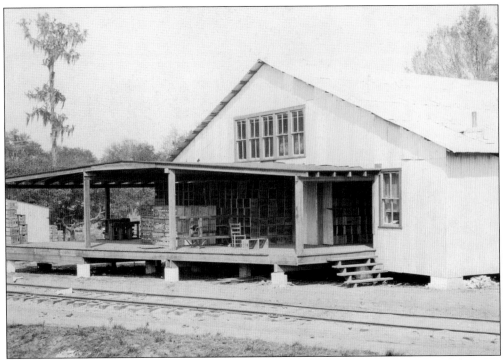

Dade City Packing House was located by the rail tracks at Eighth Street. (Photograph by H.A. Kelly; Sparkman Collection.)

The Dade City Ice Plant provided a popular commodity in early Dade City. An advertisement in the 1911 phone book proclaims, "Ice Plant—Crystal Pure Ice-blocked & crushed, catering to hotels, restaurants, institutions with delivery service, 507 East Main." (Sparkman Collection.)

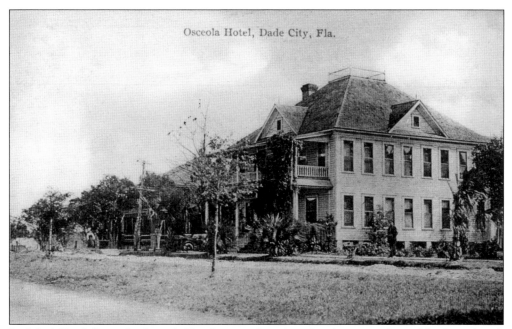

Built by M.L. Gilbert, the Osceola Hotel was used as a boarding house; workers of the Sunnybrook Tobacco Co. and L.B. McLeod Company were frequent residents. It was later operated by Minnie Cochrane; succeeding Cochrane was beloved Rose Fyffe, commonly known as "Aunt Rose." (Sparkman Collection.)

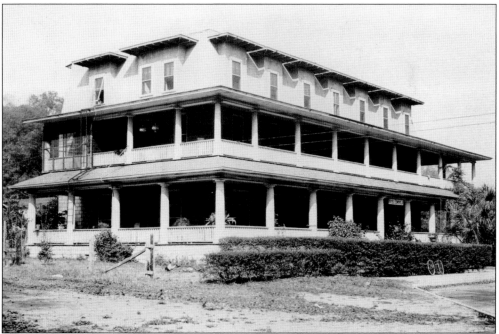

The Edwinola Hotel was built in 1912 on the site of the Dade City Hotel, which had burned in 1909. Edwin and Lola Gasque's names were cleverly combined in the creation of the name. The Seaboard train was known to swing by for its passengers to enjoy dining. It was restored and reopened in 1974 and later converted to an assisted living center. (Courtesy of Miller.)

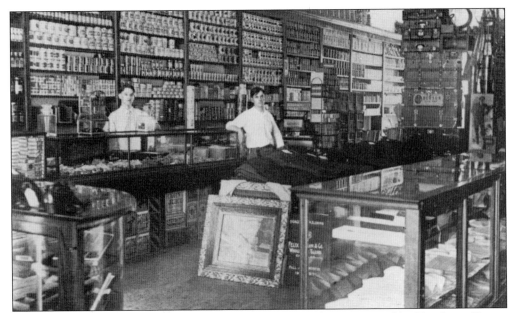

R.R. Ferrell's Gent's Furnishings & Fancy Groceries was later occupied by Touchton Drugs. The 1911 directory contains an advertisement that reads, "R.R. Ferrell—Undertaker & Gent's Furnishings—shoes-hats & high class tailoring; phones—day: 27 and night: 38." (Courtesy of Dayton.)

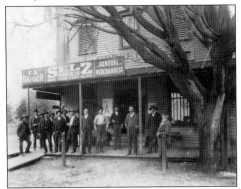

F.S. Daiger ran the Garner & Daiger Variety Store. Daiger later built a brick structure that druggist Fred L. Touchton purchased in 1922. (Courtesy of Miller.)

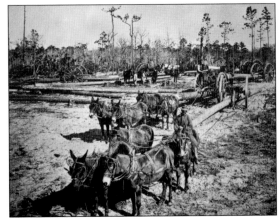

A lumber operation near Dade City in the 1920s shows the determination of industrious men and the brute strength of mules needed to harvest timbers. (Courtesy of Dayton.)

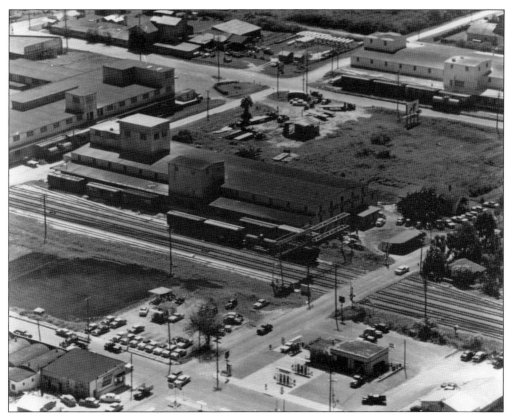

Pasco Packing was the largest single citrus processing plant in the world, and had nearly 3,000 workers. Its origins trace to 1936, when three growers, LaMarcus Edwards, Herbert Massey, and Franklin Price, formed Pasco Packing Association, a fruit cooperative and leader in Florida citrus. It was known as an originator of single-strength juices, widely distributed to World War II soldiers. It also pioneered the development of frozen orange juice concentrate. Until its closing in 2005, it was also an important part of the Dade City economy. (Photograph by Burgert Brothers, courtesy of Hillsborough Public Library.)

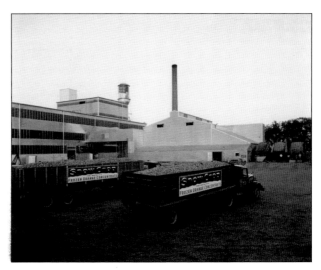

Pasco Packing Plant was located north of town on Highway 301. While driving through Dade City, the aroma of cooking oranges was often prevalent when the plant was processing. A vintage post card states: "World's largest citrus processing plant. Pasco Packing Company, Dade City, Florida. Packers of *Old South, Floridagold, Pasco* and *Vitality Dispenser-pak brands*, private labels, & bulk concentrate." (Photograph by Burgert Brothers, courtesy of Hillsborough Public Library.)

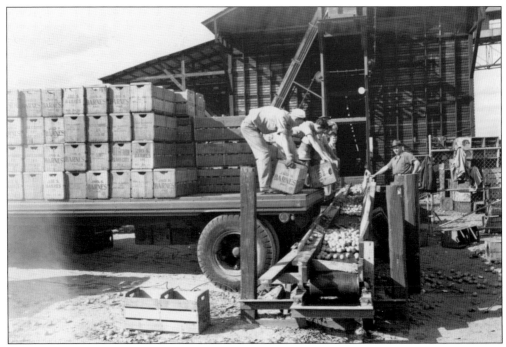

Bill Blalock wrote in the November 29, 1953, *Tampa Tribune*, "Home of the largest citrus processing company in the world . . . Close estimates are that citrus gives Dade City income of $600,000 a year; cattle another $400,000, and poultry about $500,000 a year." This 1946 photograph shows Pasco Packing. (Courtesy of West Pasco County Historical Society.)

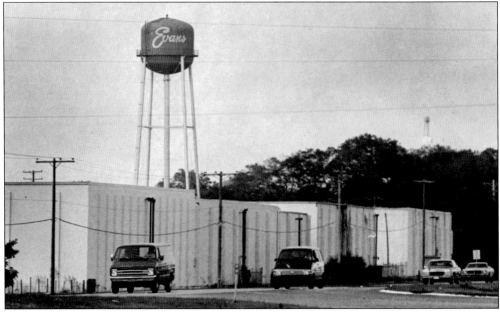

Evans Properties Inc. was formed in 1951, and was at one time the world's largest privately owned facility for bulk citrus concentrate production. Emmett Evans supplied packagers with drums of bulk concentrate for distribution to chain stores. (Photograph by Pam Higgins, courtesy of Pioneer Florida Museum and Village.)

Six

INSTITUTIONS AND ESTABLISHMENTS

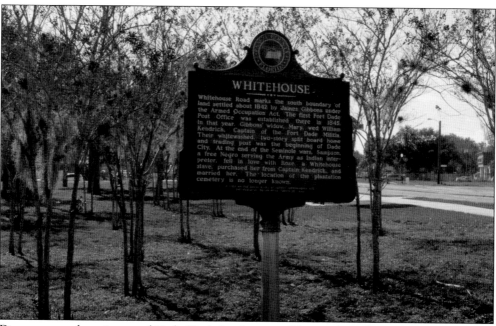

Diverse groups have impacted Dade City's development. This marker is located on the median of US Highway 98 and 301 (on the bypass-east side), and states that Whitehouse Road marks the south boundary of land, settled about 1842 by James Gibbons under the Armed Occupation Act. Gibbons's widow, Mary, wed William Kendrick, captain of the Fort Dade Militia. Their whitewashed, two-story split-board home and trading post was the beginning of Dade City. After the Seminole Wars, Sampson, a free black man serving the Army as Indian interpreter, fell in love with Rose, a slave from Kendrick's Whitehouse Plantation, purchased her from Captain Kendrick, and married her. The location of the plantation cemetery is no longer known. (Courtesy of Miller.)

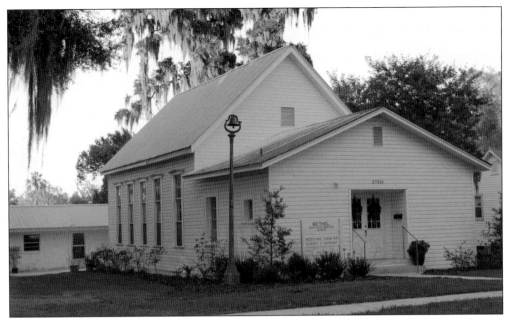

Built in 1885 as a schoolhouse in Indian Lake, north of Dade City, Bethel Primitive Baptist Church's congregation (organized in July 1888) voted in May 1896 to buy this school building and then the lot for $10. The building was moved to the north side of Church Avenue between Fifteenth and Sixteenth Streets in 1910 and expanded. The oldest portion of the church contains the one-room school building, where church members have worshipped since 1910. (Courtesy of Wise.)

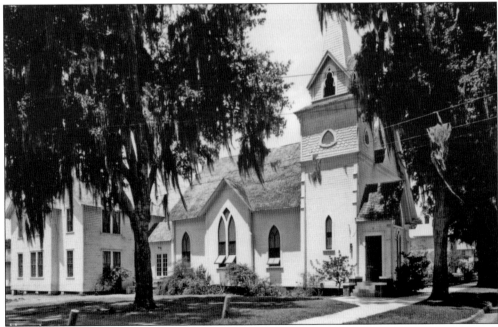

The First United Methodist Church is on the south side of Church Avenue between Eleventh and Twelfth Streets. Some of the structure dates to 1889, when a pioneer named James E. Lee moved to the area via horse-drawn wagon from Georgia. The first wedding held in the new church building was that of his daughter, Annie Elizabeth Lee, in 1889. (Courtesy of Fletcher.)

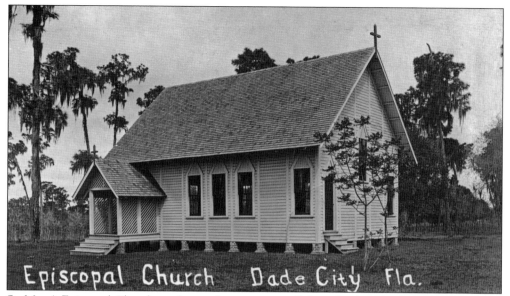

Episcopal Church Dade City Fla.

St. Mary's Episcopal Church, at the northwest corner of Magnolia Avenue and Eleventh Street, was previously the site of Terrence and Nellie Treiber's residence. Organized in October 1891 for Anglican settlers, the sanctuary was built in 1892 and enlarged in 1975. The first priest was James Neville-Thompson. The congregation moved from its first site on the west side of Lake Pasadena to the Lock house in Dade City in 1895. In 1909, they moved their old Victorian Revival–style building to its current location for $300. In 1921, they added a sacristy; in 1927, a chancel; and in 1938, Leach Parish Hall. (Courtesy of Herrmann.)

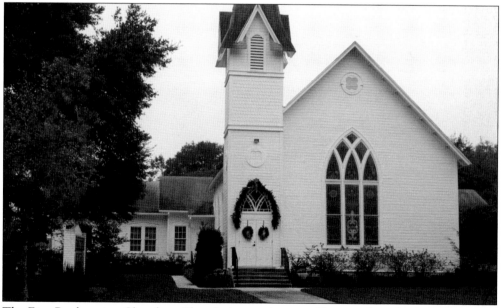

The First Presbyterian Church at Church Avenue between Fourteenth and Fifteenth Street is one of the oldest operational churches in town. It was organized on January 13, 1889, by Rev. L.H. Wilson, an evangelist of Florida's Saint John's Presbytery, which had 25 members. Wilson served until 1894, when the Presbytery appointed Arthur Rowbotham, giving him a salary of $200 a year and housing. (Courtesy of Miller.)

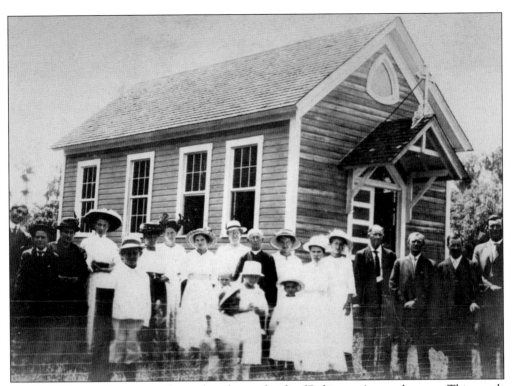

The St. Rita congregation, now located on the north side of Robinson Avenue between Thirteenth and Fourteenth Streets, was established as a mission in 1913. As Dade City became a haven for snowbirds, visitors complained of the long trek to St. Leo Abbey for Catholic services. Mary Lauinger, a frequent visitor from Pittsburgh, petitioned the abbey to build a mission church in Dade City, and offered to pay for much of the construction. W. Irving Porter sold the land to the abbey for $1, and the prospective parishioners labored to build the previous St. Rita Catholic Church (Dade City Garden Club building). They celebrated their first mass in 1913 with Father Aloysius Delabar. (Courtesy of St. Rita Church.)

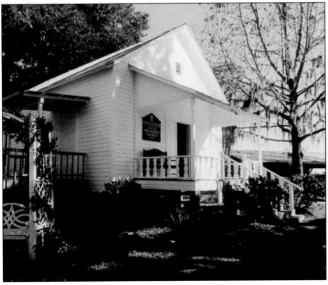

The Enterprise Church opened in 1878. The marker on the church lists charter members as Bishop D.S. Legget, P.E. Jordan, Robert Sumner, Jane Sumner, David H. Thrasher, Cary Sumner, Mary Sumner, Willis Thrasher, James Shearer, Jane Shearer, F.A. Barnes, Mary Clement, Elizabeth Tucker, and W.H. Parker. It was moved to the Pioneer Florida Museum and Village in 1977. (Courtesy of Wise.)

Withlacoochee Missionary Baptist Church (approximately five miles from downtown via a bypass to River Road) was established August 24, 1886. Building committee members included Robert L. Bryant, Elam "Eli" Larkin, H.M. Lanier, W.C. Sumner, J.R. Sumner, and Thomas F. Campbell. The building was originally the P.A. Mong Store in Richland. It replaced the original structure. (Courtesy of Wise.)

The Withlacoochee Missionary Baptist Cemetery adjoins the church grounds and contains an array of monuments dating from the early 19th century. The unique pictorial stone shown here is that of T.F. Campbell (February 2, 1876, to June 22, 1944) with an adjoining stone for his wife, Leola Ann Campbell (January 8, 1887, to March 7, 1953). (Courtesy of Wise.)

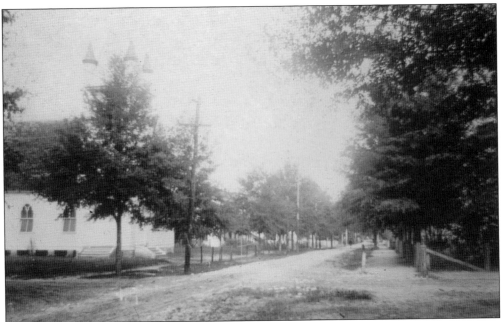

First Baptist Church is a focal point on Church Avenue today, as was College Street Baptist Church, depicted in this 1911 postcard. (Courtesy of Jernigan.)

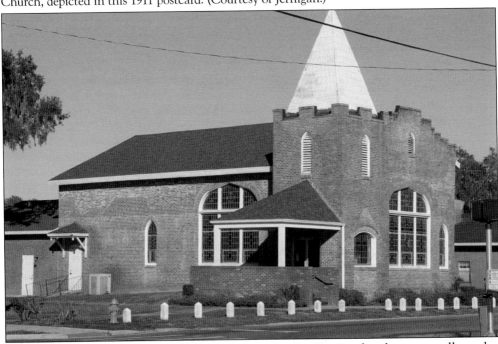

Organized in 1896 with Henry Williams as pastor, the first Baptist church was a small wooden structure at the corner of Martin Luther King Jr. Boulevard and Seventh Street. It was dedicated on August 12, 1896. The congregation thrived, and its present brick structure, St. Paul Missionary Baptist Church, was dedicated on January 1, 1920, by Rev. C.J. Smith and Dr. L. Waiters. The 100th anniversary was celebrated in 1996 with the theme, "We have come this far by faith." A baptism pond nearby on Eighth Street served many congregations. (Courtesy of Wise.)

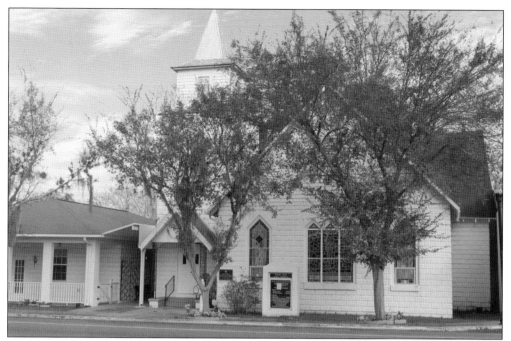

Mount Zion African Methodist Episcopal Church at Seventh Avenue between Robinson Avenue and Martin Luther King Jr. Boulevard has a historical marker that reads, "Organized in the late 1800s at Lake Buddy, this congregation moved into Dade City and became known as Mount Zion AME Church. In 1903, with 29 members, a frame meeting house was built. The present edifice, with its distinctive steeple and stained glass windows, was dedicated in 1920 and was the first Protestant church of masonry construction in Pasco County. God has blessed Mount Zion through its storms and tempests." (Courtesy of Wise.)

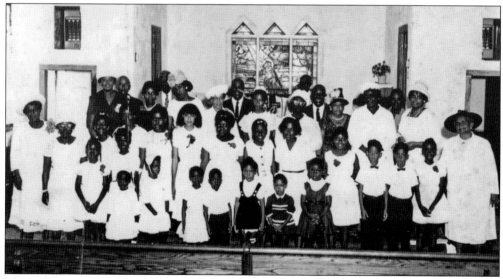

Mount Zion AME Church congregation, seen here around 1963, included Arrewintha Carter. Her grandmother, Lillie Nance, is the granddaughter of Benjamin Baisden, who was a founding father of the Mount Zion AME Church. (Photograph by Mount Zion AME Church, courtesy of Jeff Cannon.)

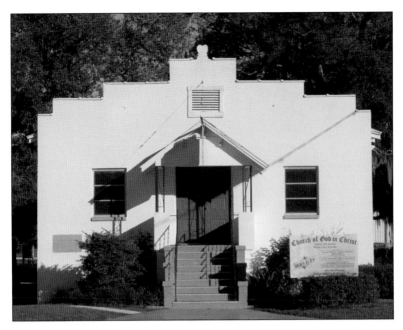

The plaque affixed to the mission-style Church of God, at the southeast corner of Seventh Street and Pond Avenue, states, "The Church of God In Christ—built by Elder T. B. Belford, A.D. 1952 with trustees, Annie Quarterman, Emma Woodard, Mamie Thomas, Eddie Roberts, Ellen Chism, and Willie Mae Hall." (Courtesy of Wise.)

The Saint John's Missionary Baptist Church is at the northwest corner of Eighth Street and Sumner Avenue. The Dr. Martin Luther King Jr. Day celebration is hosted annually among churches. Irene Dobson said, "This is something we just started doing and it works every year . . . so important, it raises money for scholarships; and education was Dr. King's dream." In 2002, the program included a community youth choir from area churches and a proclamation from Dade City mayor Scott Black. (Courtesy of Wise.)

The Dade City Church of Christ is on the northwest corner of Magnolia Avenue and Twelfth Street. The building was demolished, and soon after, a new concrete block building replaced it in the 1950s. Some residue of the old building can be found in the grassy parking area. Parishioners around the 1940s can be seen inside the church in the next photograph. (Sparkman Collection.)

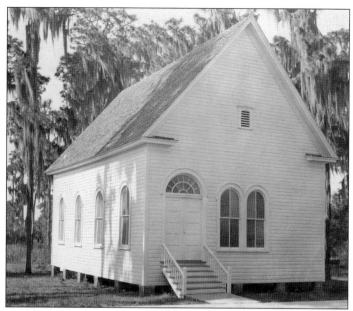

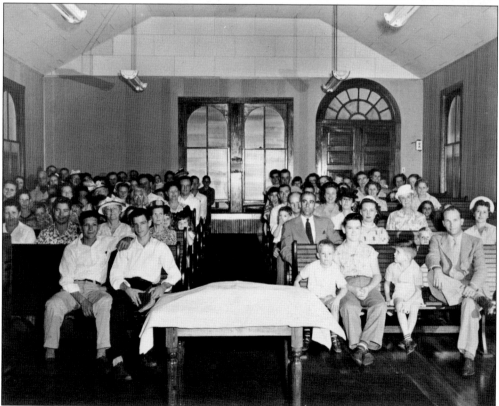

The congregation poses for a photograph in the wooden pews. Visible is the communion table, covered with the customary white cloth, which served the purpose of protecting the unleavened bread and unfermented grape juice used in Communion from flies and other insects. (Photograph by Jimmy Cravens, courtesy of Black.)

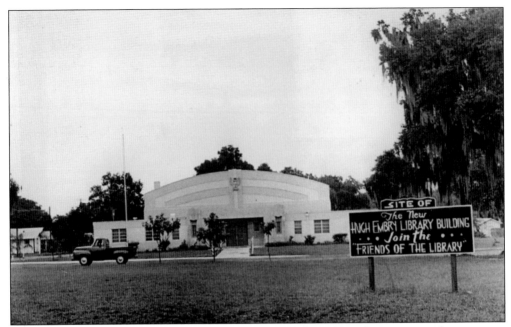

The Hugh Embry Library building project was underway by 1955, and a promotional enticement was posted at the Armory: "Site of the New Hugh Embry Library Building . . . Join the Friends of the Library." The Hugh Embry Library, located on the northeast corner of Fourth Street and Meridian Avenue, was inspired in 1904 by Hugh Embry, who was recuperating and looking for books to read. He sought donations, which resulted in a small library in the Embry home. From his efforts, the Pasco County Library Association was born. Later championed by the Dade City Woman's Club, the library relocated several times. The armory is at the north side of Live Oak Avenue between Fourth and Fifth Streets. (Courtesy of Miller.)

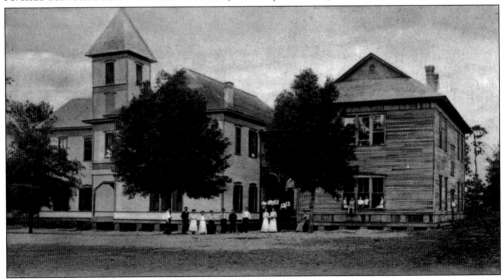

Gainesville's *Florida Sun* advertised the South Florida Normal Institute in Dade City on October 13, 1907. The college-like certification program provided teaching certification for a variety of grades. The posting boasts that certification would raise one's salary. Professor Rev. Ptolemy "P.W." Watkins Corr was the head instructor from 1907 to 1917. (Courtesy of Miller.)

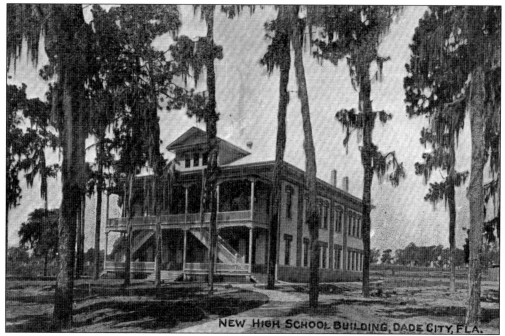

Built in 1913 by the L.M. Eck Company, the Pasco High School building replaced a pre-1900 building. Carrie O'Neal was the first graduate in a class among eight girls. (Courtesy of Jernigan)

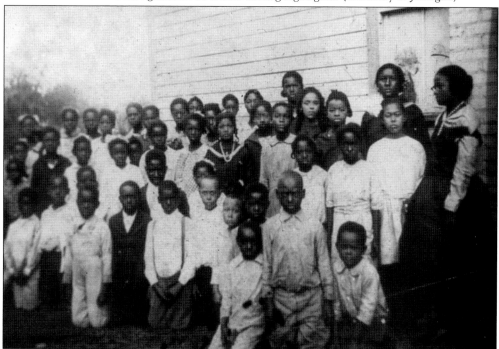

The first official school in Dade City to serve African-American students was at Sixth Street and Main Avenue (Martin Luther King Jr. Boulevard) at the Odd Fellows Hall, next to Saint Paul Missionary Baptist Church. The teacher shown in this photograph is Marie Lucas. (Courtesy of Eddie Herrmann.)

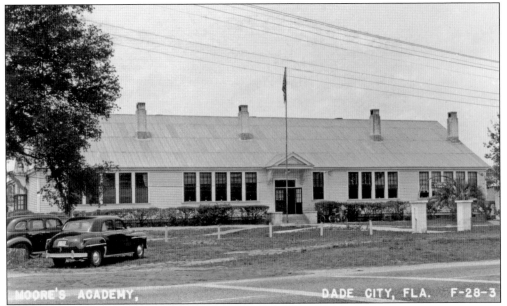

Moore Academy, named for Rev. J.D. Moore, was the first public school for African American children from the late 1920s to 1950s. Julius Rosenwald, part owner of Sears, Roebuck & Co., donated matching funds for the school—indicative of the millions he donated for education of African American children in the rural south. Schoolmasters included J.E. Moore, Etta Burl, and O.K. Mickens. The school succumbed to fire in 1933, thought to be an act of arson shortly after Prohibition ended. O.K. Mickens and James Irvin organized the School Aid Club after the fire to provide schooling. Eventually, they expanded to grade 12 in 1937. Mickens High School was built in 1956. (Courtesy of Miller)

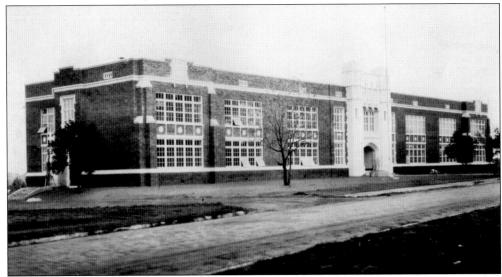

Built under the direction of Artemus Roberts and financed by bonds in 1927, Dade City Grammar School is an example of Tudor Revival/Collegiate Gothic. The site was formerly the John C. Overstreet homestead. This is a 1928 photograph of the $150,000 building, which was renamed for Superintendent Rodney B. Cox, who died of cancer while in office in 1973. (Courtesy of Pasco County Fair Association.)

This Pasco High School building was constructed in 1949. The first class graduated in 1948 before it was completed, and the last graduation at the site was in 1970. The *Dade City Banner* reported: "1970 went down in history as the last time two Dade City high schools will have graduations." The building was utilized as Pasco Junior High, and later Pasco Middle School, until it was demolished in 2010. (Courtesy of Carey.)

Pasco Elementary School students participate in a parade in downtown Dade City around 1960. Pasco Elementary School opened for grades 1–6 in 1955, with Joseph B. Benson as principal. Dallas T. Parker served as principal from 1957 to 1981. The school is situated on Florida Avenue between Fourteenth and Fifteenth Streets. (Courtesy of Wise.)

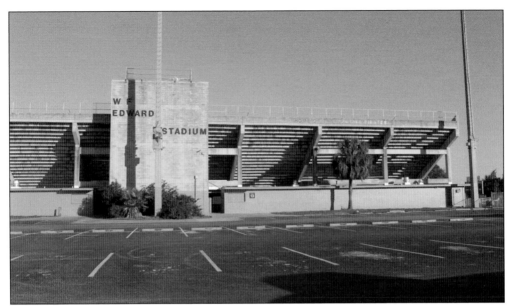

William Ferguson "W.F." Edwards was the fundraiser responsible for the $350,000 Pasco stadium, which replaced the former Massey Field. The Pirates opened the season against Wildwood in 1965. By 1970, when the campus of Pasco High relocated adjacent to the stadium, the stadium project was paid in full. It was renamed for Edwards, son of L.C. Edwards, founder of Pasco Packing. W.F. was inducted into the Florida Citrus Hall of Fame and died in 1992—the same season the Pirates became the county's only state football champion. (Courtesy of Wise.)

Pasco Comprehensive High School's industrial style reflects the 1970s era. The Dr. Donald McBath Activity Center on campus was named for McBath, a Pasco Physician of the Year, who was sports team doctor for 25 years. Dade City was cheering on their home team on December 18, 1992, when they won the Florida state football championship by defeating Tampa Jesuit 28–16. Among the players were future Dallas Cowboys running back Troy Hambrick and future NFL linebacker Darren Hambrick. (Courtesy of Miller.)

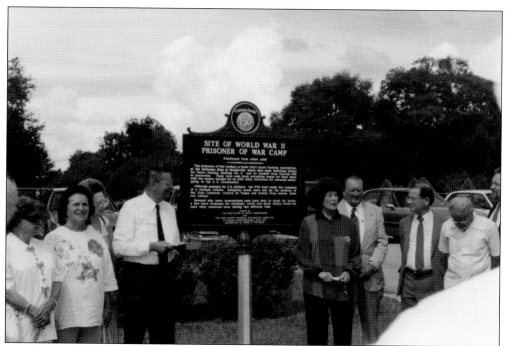

Prisoner of War–Branch Camp No. 7 was located a short distance southeast of present-day Pyracantha Park. It housed an average of 250 POWs from March 1944 until the spring of 1946. Many were from Rommel's Afrika Korps. The demands of World War II created a shortage of agricultural workers, and the POWs helped supplement labor. Built by the US Army Corps of Engineers, the camp had a three-tent mess hall, a canteen attached to a small day room, and a larger day room with table tennis and a piano, sleeping quarters, and latrines. The dedication of the monument on October 1, 1995, included Jewel Atkinson, Shirley Hudson, Lela Futch, Bill Maytum, Sylvia Young, Hap Clark, William G. Dayton, Charles Arnade, Richard Diamond, and Eddie Herrmann. (Courtesy of Black.)

The POWs worked at Pasco Packing; at McDonald Mine in Brooksville, where they made limestone bricks; and Cummer Sons Cypress Mill in Lacoochee. They were paid local wages with 80¢ taken for board. Eddie and Patsy Herrmann, local historians, have been friends with many of the former POWs, such as Lü Herder and Werner Burkert, who have visited. Heinze Friedmann, who was interned at the camp, painted this mural. (Courtesy of Pioneer Florida Museum and Village.)

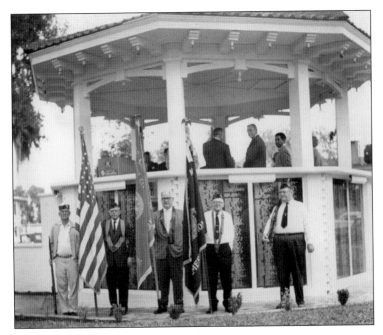

The World War II Memorial in Dade City was dedicated on Flag Day, June 14, 1954, and re-dedicated on June 14, 2014. It is part of a bandstand on the northeast corner of the historic courthouse square. On the memorial are 1,855 names. The photograph, from Veterans Day in 1963, shows area veterans performing a flag ceremony. (Courtesy of *St. Petersburg Times*.)

Oak Grove Baptist Church and Cemetery was established in the early 1870s by Rev. R.E. Bell. Church minutes from 1877 describe the location as Oak Grove, Florida. By 1886, it was referred to as Dade City Baptist Church. In the early 1890s, the congregation migrated to other local churches. This photograph shows some of the earliest gravestones, some of which date to the 1850s. (Courtesy of Wise.)

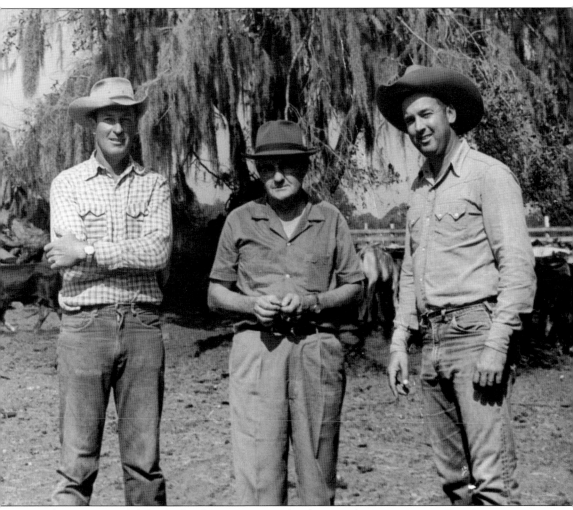

Early in 1960, Rudolph Rhode of San Antonio, Florida, gave the Pasco County Fair Association 37 vehicles and large historic farm tools. Daniel A. Cannon helped to obtain this collection to originate the Pioneer Florida Museum and Village. James F. Higgins (at center, with J.W. Barthle and Albert Barthle) was fair manager and worked diligently to help form the museum organization in March 1961. Eighty-seven members were secured and a charter was granted by the state to the Pioneer Florida Museum Association. Officers were president C.A. Clayton, vice president Joe Herrmann, secretary Mrs. E.A. Roberts, and treasurer James Futch. (Courtesy of Pasco County Fair Association.)

"We began when a group of concerned citizens got together and realized a way of life was passing," said Mary Louise Brock, granddaughter of the Gasques of Edwinola fame. Housed for years on the fairgrounds, the museum moved to the Pioneer Florida Museum and Village to its current location after the late William Larkin donated ranch land. "Most items in it and the historic structures were donated," Brock said. At the time of this photograph in 1975, she had been a volunteer for 25 years and was president of the museum board. (Courtesy of Tampa-Hillsborough Public Library.)

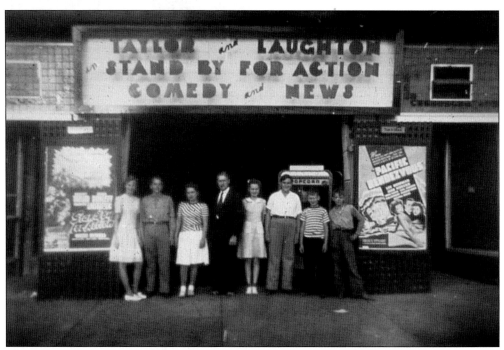

The Crescent Theatre, on the northeast corner of Fifth Street and Florida Avenue, was Dade City's principal theater for a generation from the peak of the Florida Boom to after World War II. It was constructed in 1926 by A. Garcia and I.M. Austin. The Mediterranean-style theater was designed to be part of Crescent Park that never came to fruition. By 1945, traffic patterns in Dade City had changed, and the Crescent no longer stood on the main thoroughfare as it had in the 1920s. Floyd Theaters shifted the movie house to Pasco Theatre on south Seventh Street and sold the Crescent building to Alexander Buick in 1950. It now houses the CARES Crescent Center. (Photograph by Alice Hall, courtesy of Eddie Herrmann.)

The Pasco Theatre opened in December 1948. The theater was demolished in 1999 and a bank was constructed on the site. The theater was an art deco–style building. Jumbo posters, reaching from the sidewalk to the marquee, flanked the entrance that included a standalone glass booth. It featured the main level and a balcony. (Courtesy of Florida Department of Commerce, Motion Picture, and Television Bureau.)

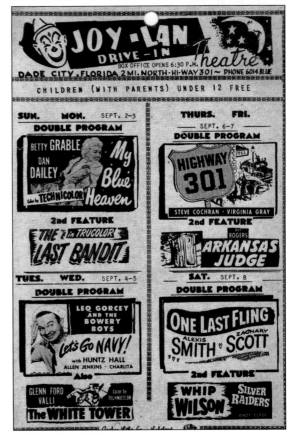

The *Dade City Banner* reported that the Joy-Lan Drive-in Theatre opened March 9, 1950, with the showing of *Challenge to Lassie*, starring Edmund Gwenn, Donald Crisp, and the legendary collie. Contractor Ed Jenner built about 20 other theaters throughout the country during the previous two years. It continues to operate. (Courtesy of Miller.)

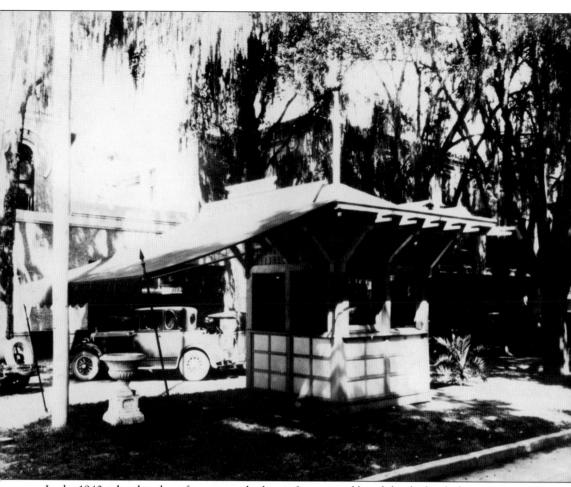

In the 1940s, the chamber of commerce had an informational booth by the bank that was situated on a median for drive-up information. As needs increased, it was housed near the courthouse in 1962. (Photograph by Holcomb; Sparkman Collection.)

Seven

OUTSIDE OF DADE CITY PROPER

As a rural area, Dade City anchors a variety of surrounding locations that depend upon her for shopping, recreation, education, culture, and an expanded sense of community. The symbiosis of these towns and villages has shaped the local history. An 1895 atlas shows these places in Pasco County, some with recorded populations: "Abbott; Argo; Big Cypress; Blanton; Chipco, 13; Dade City, 321; Drexel; Earnestville, 72; Ehren; Ellerslie; Godwin; Hegman; Hudson, 16; Jessamine; Keystone Park; Lacoochee; Lenard, 101; Macon, 133; Milliards; Odessa; Owensboro; Pasadena; Pedrick; Port Richey, 27; Richland; San Antonio, 252; Saint Leo; Saint Thomas, 202; Twin Lakes, 76." (Photograph by Burgert Brothers, courtesy of Tampa-Hillsborough Public Library.)

Built in 1855, the Lanier Bridge facilitated lumber, turpentine, and cattle operations, along with extinct settlements such as Ashley and Titanic. During the Second Seminole War, Old Tiger Tail, a prominent chief, made his camp in swamps near the river. Around 1900, the Campbell family operated a cypress shingle factory on the west side of the river north of the bridge. During Prohibition, many illicit whiskey stills operated in the area. (Courtesy of Miller.)

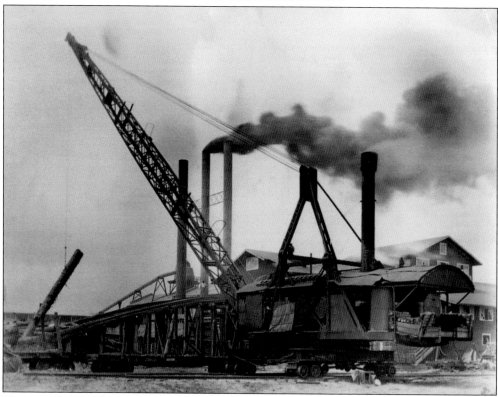

Cummer Cypress Company wrote a great deal of Lacoochee history when it arrived in 1922, set on mining virgin cypress from the Withlacoochee and Compressco swamps. Acquiring over 50 square miles of land, it was a major employer. A company town, Compressco, located in the northeast corner of Pasco, was reached by road from the Lanier Bridge. The sawmill closed in 1959. (Courtesy of Miller.)

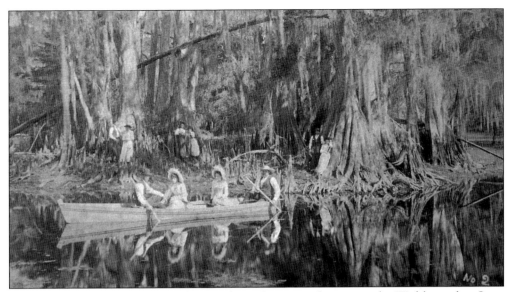

People boating on the Withlacoochee are shown here near the present-day Withlacoochee State Trail. In the late 1800s, Henry Plant established a rail line that ran from Croom to Inverness, thus completing the Plant Systems West Coast Route. It became the Atlantic Coast Line in 1902, then Seaboard Coast Line in 1967, and finally CSX Transportation in 1980. In 1989, CSX sold the 46-mile right-of-way that became Withlacoochee State Trail, the longest paved rail-trail in Florida. Hiking, biking, and equestrian paths, as well as habitat protection areas, abound. (Courtesy of Robert Ramsey.)

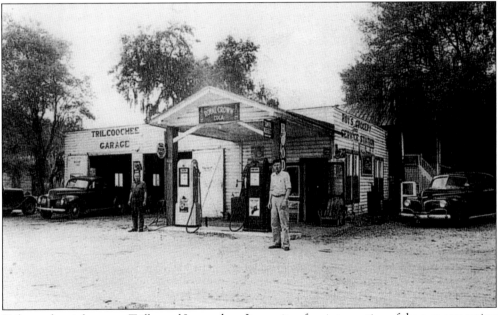

Trilacoochee is between Trilby and Lacoochee. It was site of an intersection of the two competing railroads, complete with a switching station. Trilacoochee boasted a school, post office, brickyard, and the Lutz Brothers shingle mill. With shifts in dependency on rail, it has become known in recent years for the Withlacoochee Trail. The Causey Garage was an early gas station in the area. (Courtesy of Miller.)

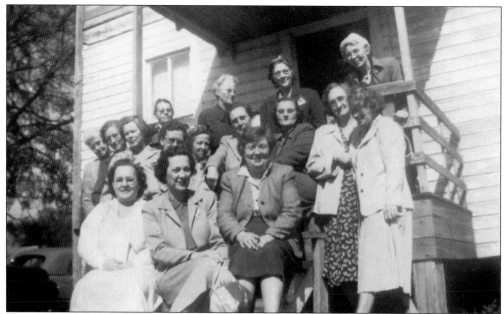

In 1886, the town of Trilby (previously Macon & McLeod Settlement) had a population of 130 with six stores, two steam sawmills, school, church, and hotel. Its economy was dependent on citrus and vegetables. This photograph shows the Home Demonstration Club posing in front of the Trilby Masonic Lodge in 1951. Members are Bessie Cannon, Bernadette Chesbro, Myrtle Davis, Flossie Edwards, Verna Free, Gertrude Greshem, Ethel Mingus, Jesse Moore, Allie Prevatt, Lenessa Richardson, Mary Stearns, Leota Whittington, Elizabeth Wilkes, and Georgianna Woodburn. Not shown are Velma Burney, Katie Carlisle, Thelma Farr, Mrs. William Gould, Exa Hicks, Minnie Hopkins, Missie Morgan, Ruth O'Berry, and Hattie Tyer. (Courtesy of Pasco County Fair Association.)

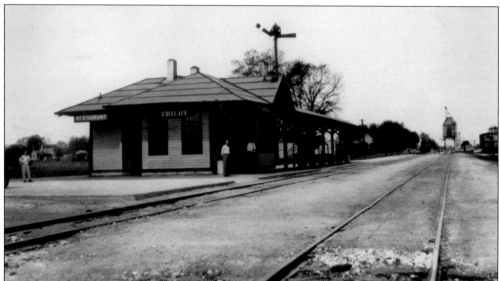

Trilby's name is derived from a popular 1894 novel by George DuMaurier entitled *Trilby*. The town was significantly impacted by a 1925 fire that destroyed many of the vital buildings. (Courtesy of Black.)

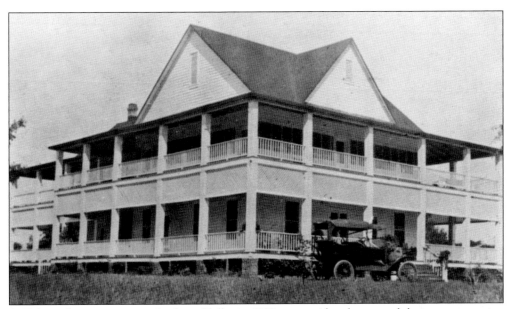

A Tuberculosis sanitarium, built in Trilby in 1912, was said to be one of the most attractive sanitariums in the United States and much needed in central Florida. The building later succumbed to fire. (Courtesy of Herrmann.)

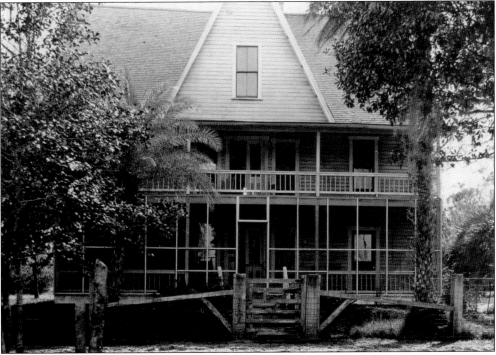

Wilma Ellsworth wrote, "Communities come into being and pass out of existence . . . one east Pasco community was left with a lovely name—Jessamine. In 1887, Walter Pike and William Ellsworth founded the town, which started as a seed/plant business about five miles southwest of Trilby. They called their firm Jessamine Gardens." The photograph is of the Ellsworth residence. (Sparkman Collection.)

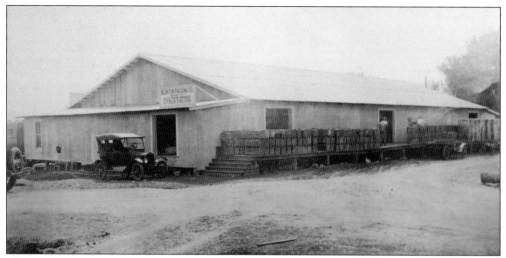

Blanton was a country outpost with a school, church, store, and the Evans Brothers Shingle Mill. First settled in 1884, with land selling for $10–$30 per acre, it was named for Jesse Blanton, one of the first settlers. Dependent on lumber and turpentine, Blanton Packing Co. opened in 1924 and shipped various labels. (Courtesy of Lora Blocker.)

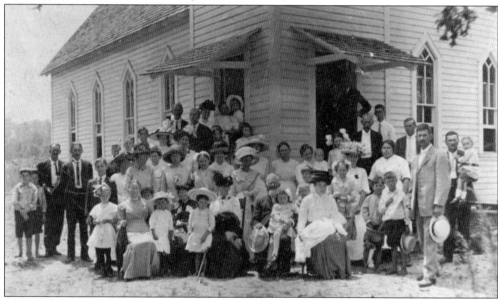

This church was built in 1906 by Will Heacock and Tom Jordan on land donated by Mr. and Mrs. Henry P. Blocker. People in the photograph are believed to be (first row) Fleta Blocker, Mary Woodburn, Marge Dowling, Grandma Sarah L. Ansley, ? Butler, Mrs. Butch, Samuel J. Ansley, ? Chambers, Amanda Chambers, Cornelius Green, Louis Dowling, and Sanford Blocker; (second row) Homar Jordan, ? Bonaparte, Hugh Butler, William Ellsworth, Elroy Ellsworth, Julia Downing, Mrs. McAdams, Florence Ellsworth, Beatrice Ellsworth, Newell Mayo Rabb, Emily Blocker, Mrs. McNese, Luciree McNese, Mattie Platt, Annie Adams, and Will Chambers; (third row) Susan Mayo, Oletha Ellsworth, and Mrs. Ellis; (fourth row) Ralph Bessenger, two unidentified, Sally Adams, Mr. Coreen, Rev. A.M. Mann, L.W. "Ora" Lipsey, Mattie Loli, Grace Jordan, Gladys Adams, Louise Adams, Mattie Woodburn, Anna Lee Woodburn, Mr. J.L. McDaniel, Jack Dowling, Lucien Lipsey, and Bob Adams. (Courtesy of Lora Blocker.)

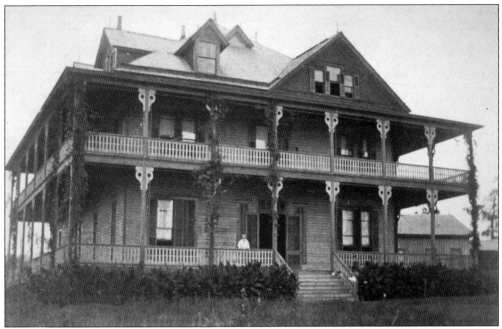

Residents near Lake Jovita met at the home of Dr. J.F. Corrigan on February 24, 1891, to incorporate their town as Saint Leo. Not surprisingly, Corrigan was the first mayor. Saint Leo was the first town in the county to pass a "no fence" law to abolish the nuisance of stray cows and hogs destroying crops. Within the nucleus of attractive homes and thriving groves was Saint Leo College and Prep School. (Courtesy of Miller.)

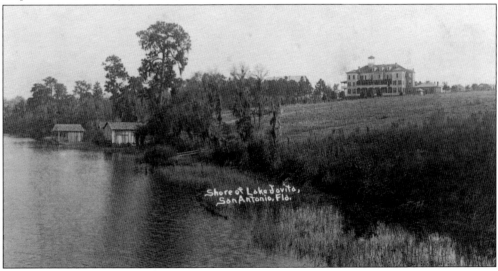

Judge Dunne established the colony on land he received for legal services for negotiating the Disston purchase for four million acres from the state at 25¢ an acre. The colony was named to honor Saint Anthony of Padua in thanksgiving for an answer to prayer. "The town of San Antonio is on the very apex of all the high land in that region . . . it thus gets the breezes off the Atlantic on the one side and the Gulf on the other," said Judge Dunne in 1881. Dunne named Lake Jovita in honor of the Feast of Saint Jovita, when he visited the lovely body of water. (Courtesy of Miller.)

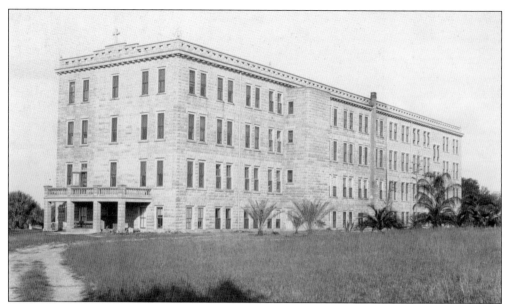

Saint Leo Abbey was founded in 1889 and the college (now Saint Leo University) opened in 1890. The town of Saint Leo was founded in the 1880s and incorporated in 1891. (Sparkman Collection.)

The Darby exhibit at the 1967 county fair shows off the community's agricultural roots. The *Florida Gazetteer* reported in 1886 that mail ran on Tuesday and Friday and land sold from $5 per acre. Darby had a flouring mill run by waterpower, a school, and church, with oranges as its principal shipment. (Courtesy of Pasco County Fair Association.)

Saint Joseph, founded in 1885 by German Catholic immigrants Andrew Barthle and Bernard Barthle, was initially called Barthle Settlement. J.A. Barthle is seen here standing in front of the post office. (Courtesy of the Pioneer Florida Museum and Village.)

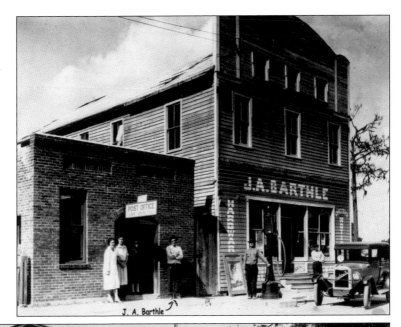

Dade City is known for the annual Kumquat Festival. The Kumquat Growers Association Inc. is based in Saint Joseph. Celebrity Roger Swain, host of *The Victory Garden* on PBS, lectures on kumquat history annually at grove tours. Frank and Rosemary Gude and Joseph and Margie Neuhofer are the owners of Kumquat Growers Inc. Officially established in 1885, Saint Joseph has a long history of agriculture that includes strawberries and mainstream citrus. C.J. Nathe realized the potential of kumquats when he worked at Jessamine Gardens. They sell over 2,500 kumquat pies at the annual festival. Residents remark that the kumquat now replaces an orange on the former Pasco Packing Plant's water tower—once the largest citrus operation in the world. (Courtesy of Wise.)

Lake Iola, near Saint Joseph, was known for swimming, recreation, a dance hall, and cottage rentals. The business name, as depicted on the boat, was "Ward's Lake Iola." Margie Fagan is pictured in 1951. (Courtesy of Carey.)

Pasadena, located southwest of Dade City, had a brief history from 1880 to 1895 as a resort. The Lakeview Highlands Hotel was an exclusive social center, which lost clientele after the citrus freezes. It was purchased by the Methodist Conference and was used by the Fort King Home Demonstration Club; it later became Pasadena Church. The first known residents of this area however, date to the 1780s, when Eufala Seminoles settled the village of Toadchudka. (Courtesy of Carey.)

The Linda Vista country store on LeHeup Hill of Fort King Highway is one of the highest points geographically in Pasco County. Named for William A. LeHeup, Fred T. and Lizzie Himmelwright operated a country store there beginning in 1927. One could gaze out on a variety of communities from the vantage point of a glass observatory room on the top of the store. (Courtesy of Miller.)

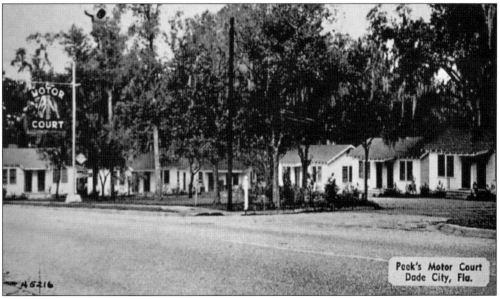

Peek's Motor Court postcard states, "Citrus canning center which is downtown on scenic highway US 301 and US 98, one-half block from theatre with good restaurant nearby. Private tile tub and shower baths—Latest heating system, cold and hot water—Mr. & Mrs. J.W. Jones." Former mayor Scott Black said, "Have you ever noticed that if you take Highway 301 north from Dade City to Georgia, it can be reminiscent of Route 66 with quaint motels and former attractions?" (Courtesy of Black.)

DISCOVER THOUSANDS OF LOCAL HISTORY BOOKS
FEATURING MILLIONS OF VINTAGE IMAGES

Arcadia Publishing, the leading local history publisher in the United States, is committed to making history accessible and meaningful through publishing books that celebrate and preserve the heritage of America's people and places.

Find more books like this at
www.arcadiapublishing.com

Search for your hometown history, your old stomping grounds, and even your favorite sports team.